Digital Art Studio

Digital Art Studio

Techniques for Combining Inkjet Printing with Traditional Art Materials

Karin Schminke
Dorothy Simpson Krause
Bonny Pierce Lhotka

Watson-Guptill Publications / New York

COVER
Karin Schminke
CALLA
Gold metallic paint on center panel of inkjet print,
on commercially precoated 90-lb watercolor paper,
14$\frac{1}{2}$ × 11" (37 × 28 cm), 1997.

FRONTISPIECE
Dorothy Simpson Krause
HAPPY HOME
Emulsion transfer to plaster surface with lenticular
overlay, 48 × 48" (122 × 122 cm), 2001.

TITLE SPREAD
Bonny Pierce Lhotka
INDIGO (DETAIL)
Inkjet burnished to dry white fresco panel,
32 × 24" (81 × 61 cm), 1997.

Senior Acquisitions Editor, Candace Raney
Edited by Robbie Capp
Designed by Areta Buk
Graphic Production by Hector Campbell
Text set in 11-pt. Adobe Garamond

The experimental methods and use of products in this book have
been developed by the authors/LSK LLC. Because of the diversity of
materials, equipment, and/or conditions under which these processes
may be used, no guarantee or warranty of fitness for a particular
purpose is offered. Some of the processes may void warranties by
manufacturers of products or equipment. Each user should evaluate
these methods for suitability, and should obtain and follow material-
safety data sheets for all products.

Copyright © 2004 LSK LLC
First published in 2004 in the United States
by Watson-Guptill Publications,
a division of VNU Business Media, Inc.
770 Broadway, New York, NY 10003
www.wgpub.com

Library of Congress Control Number 2004100593
ISBN 0-8230-1342-1

Printed in Hong Kong

First printing 2004

5 6 7 8 9 / 12 11 10 09 08 07 06

Acknowledgments

We are especially grateful to the museums and
galleries that have exhibited our work and the
corporations and individuals who have purchased
and commissioned it. Both their moral and
financial support keep us going.

The University of Washington's Helen Riaboff
Whiteley Center, in Friday Harbor, Washington,
provided us with a wonderful space for scholarly
research. We credit our week there with
organizing this project and completing our first
draft of this book.

Curt Cloninger played an important role in
writing our three voices into one, while
Olympus digital cameras gave us a unified look
and John S. Shaw helped shape the glossary.
Mary Taylor, Emily Pease, and Greg and Doug
Lhotka have expertly assisted us in more ways
than we can enumerate. We were privileged to
have such superb help.

We are also grateful to MaryAnn Kearns, Joann
Moser, and George Fifield for sharing their unique
expertise. And at Watson-Guptill, we thank
Candace Raney for giving us the opportunity to
write this book, Robbie Capp for her excellent
editing, and Areta Buk for her elegant design.

Finally, we thank our patrons—the individuals
in the inkjet printing industry who provided us
with hardware, software, and supplies, as well as
technical and moral support. Without their help,
our work and this book would not have been
possible. For their ongoing assistance over many
years, we especially acknowledge: Adobe Systems;
Arches/Canson Paper; ENCAD/Kodak; Epson;
Flipsigns!; InteliCoat; Xerox/Tektronix; Lyson;
Microtek; Mutoh; Olympus; Roland; and Wacom.

Many other companies have contributed to
our success. Although some of them no longer
exist, we remember with appreciation the support
we received from: Applied Visual Concepts;
CADlink; Calcomp; CODA; DuPont; Fractal Design;
Graphic Media Products; Hahnemuehl; Hewlett-
Packard; Indigo; Intergraph; International Paper;
Iris Graphics; Jacquard Inkjet Systems; Kimoto;
Macromedia; Microlens; Mimaki; Oce USA; Paper
Technologies/Legion Paper West; Tom Howard
Imaging; and Wasatch Computer Technology.

We are deeply indebted to our husbands, Kevin, Dick, and Joe,

for their unwavering support of this book

and our many other projects and events.

We couldn't manage without them.

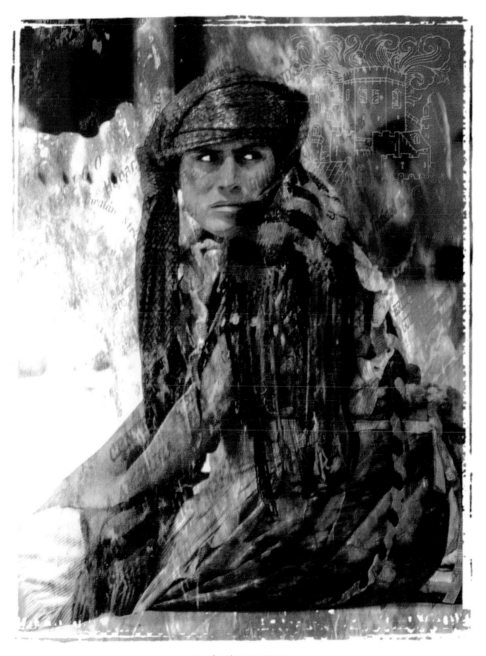

Dorothy Simpson Krause
LOOKING BACK
Inkjet transfer to watercolor paper, 47 x 34" (120 x 85 cm), 1997.

Contents

Foreword

NOT ONLY ARE the prints by the three artist-authors of this book beautiful to behold; their methods are an art in themselves. Their careful documentation of their processes in their Digital Atelier studios attests to their passion and dedication to developing and sharing their cutting-edge printmaking techniques. While expanding their personal vocabularies of form and substance, they have redefined the print. Bonny, Dot, and Karin are united by their fearless attitude toward blending new and old technologies. Their optimism and confidence steer their course of trial and discovery.

What sets these artists apart is their foresight. Early pioneers of digital printmaking, they embraced computer imaging at a time when the print was a facsimile of the image. In response, they adopted a hands-on approach to digital printmaking. From their earliest collaborative experiments, they have viewed the inkjet print as a step in the creative process.

I have had the pleasure of exhibiting and working with Bonny, Dot, and Karin for almost a decade. When I began this foreword, I looked over previous essays I had written about them and was struck by how accurate my descriptions remain. That consistency comes from the strength of their images and their meticulous craft. Their ongoing use of the latest imaging technology keeps us dazzled. The more we contemplate their prints, the more we penetrate their layers of meaning and material.

To my astonishment and envy, through the years, Bonny, Dot, and Karin have sustained their enormous creative energies and output, their expertise growing with it. While their methods continue to evolve, their explorations remain true to their personal interests and styles. Equilibrium balances their juxtaposition of old and new. Anchored by their roots in tradition and their respect for history, they always reach out in new directions. In 1997, Bonny, Dot, and Karin, with Helen Golden and the late Judith Moncrief, were Artists-in-Residence at the Smithsonian American Art Museum—an event which earned them the Smithsonian/Computerworld Technology in the Arts Award. As I wrote in an essay at that time:

"When combined action creates something greater than the sum of the individual parts, the result is synergy. Synergy is Digital Atelier—the artists, their technique, and their art. Sharing their techniques with each other, they have banded together to work and exhibit their art. Their collective energy and focus hold them together like excited electrons in shared orbit. With prescient vision and exceptional art, they are helping to define a new aesthetic.

"The artists of the Digital Atelier combine their expertise in conventional media techniques with digital imaging to produce original fine art and editions. Their varied art backgrounds and training furnish them a rich repertoire of ingenuity. The prints they create defy identification. It is the artists' finesse, not tools, that sets them apart."

The most valuable tool shared in this book is not to be found on a single page, but in the sum of the pages. It is not a process, but rather a state of mind. The mixed-media methods devised by the artists reflect their passion to fashion new kinds of images. Their enthusiasm to define and refine original printmaking techniques inspires.

Mary Ann Kearns
Curator, North Chelmsford, Massachusetts

IN 1997, Dorothy Simpson Krause, Bonny Pierce Lhotka, and Karin Schminke (with Helen Golden and the late Judith Moncrief) conducted a three-week workshop at the Smithsonian American Art Museum (then the National Museum of American Art). The artists set up some of the latest personal computers, graphic software, and color printers in a space dedicated to education programs, and invited museum staff and visitors to experiment with this wealth of technology. They worked long hours to assist everyone who needed help, from professional artists to young children. The workshop was a stunning success, and for several years afterward, the museum received inquiries about when it would be repeated.

Toward the end of the three weeks, the Digital Atelier artists each offered to donate a print for the museum's permanent collection (see page 10). A colleague and I met with them to select the prints. As we were reviewing the images, the artists asked us what size we would like our prints to be and on what paper we would like to have them printed. I could not believe my ears! Weren't these decisions the artist alone should make? No, they wanted our input and, after much discussion, we made those decisions together. The next time the image was printed, the size and paper might well be different. Would both prints be part of the same edition, or was the paradigm of the limited edition of identical impressions no longer relevant? Clearly, digital printmaking presents possibilities that challenge our traditional understanding of how prints can and should be made.

The possibilities inherent to this new medium force us to question assumptions, definitions, and values long held in the world of prints. The artist, perhaps in collaboration with a master printer, has made all the artistic decisions. Now, there seems to be a role for the collector as well. The use of a scanner can sometimes blur the distinction between an original print and a reproduction. The seamless incorporation of images from newspapers, magazines, comics, advertisements, and the Internet into the artist's digital composition pushes the limit of copyright considerations. Although the prodigious use of photography in lithography, intaglio, and screen printing, as well as the contemporary revival of interest in photogravure, had already begun to blur the distinction between photography and printmaking, digital printmaking dissolves the border even further. Is the limited edition an outdated concept? Will the computer return printmaking to its democratic roots? With digital images now being printed on such diverse materials as canvas and cookies, will paper continue to be the primary carrier for prints? Few assumptions and definitions remain inviolate in this new medium.

Digital printmaking is still in its infancy. In this book, the authors make many of its techniques and possibilities available to artists who will develop and explore its potential further. The key to creating art, however, lies not in technological prowess, but in the power of the image and concept behind it. Digital printmaking works best for art that is idea and information based. New papers and inks have expanded the possibilities for rich surfaces, but the real potential of the medium lies in the successful marriage of technique and expression, so that qualities inherent to the medium are central to the concept of the work of art.

Joann Moser
Senior Curator, Graphic Arts
Smithsonian American Art Museum
Washington, D.C.

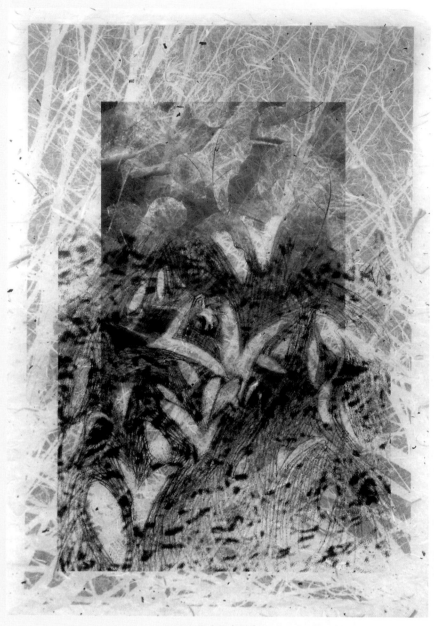

ABOVE: Karin Schminke
EARLY SPRING
Inkjet print onto both sides of thin rice paper,
34 × 22" (85 × 56 cm), 1997.

TOP RIGHT: Dorothy Simpson Krause
LADY OF THE FLOWERS
Inkjet print on textured nonwoven fabric with gold leaf,
44 × 39" (111 × 99 cm), 1997.

RIGHT: Bonny Pierce Lhotka
HIVE
Inkjet print on acrylic painting on rabbitskin-glue-coated
nonwoven fabric, 44 × 43" (111 × 110 cm), 1997.

Tools and Materials

YEARS AGO, when we chose the computer as a tool for making printed art, few artists were willing to work within the limitations of the digital medium (an eight-color palette and dot-matrix printers). We found that those limitations demanded the addition of traditional media, so we each began exploring the integration of digital printing with traditional art materials.

As recently as ten years ago, when we three began working together, inks faded quickly, there were no fine-art papers or canvases available for printers, and inkjet-printed images were both physically and visually flat. If you chose to hire one of the few existing service bureaus to make large-format prints, it was expensive, making the prints seem too precious to alter.

Large-format inkjet printers were just being developed, and we immediately identified them as tools with great artistic potential. Wanting to understand the new technologies and gain access to equipment we couldn't afford to own, we began our research. We became liaisons between other artists interested in using these new tools and manufacturers who needed to understand important artistic concerns, such as ink permanence and the ability to print on heavy papers and canvas. As we continued to experiment and use new techniques, magazines asked us to write about our findings. We began giving workshops and seminars at venues as diverse as College Art Association, Seybold Seminars, MacWorld, and the Brooklyn Museum of Art.

After all that teaching, we felt the need to document the processes we had discovered and integrated into our work. This book is the result. Ten years of experimentation with digital/mixed-media methods, previously available only in limited workshops, is presented here for artists who want to go beyond the digital print and use all the means at their disposal to integrate inkjet printing with traditional art forms. Some understanding of both digital and classic tools is recommended, but not required. All you need is a desire to experiment, be ready to "expect the unexpected," and enjoy your own discoveries.

Integrating digital printing with traditional media is an exciting and rewarding process. If you are a traditional artist, we hope this book will empower you to inject digital printing techniques into your artistic practice. If you are a digital printing ace, we encourage you to use your expertise as a foundation on which to expand your artistic expression. And if you have already begun integrating digital printing with traditional media, we hope this book will supplement your current knowledge and inspire you to take your work to even greater creative levels.

Overview

To get the most from this book, you will need access to a computer, a printer, and traditional art materials. Having a working knowledge of Photoshop is also helpful, and if you are new to digital printing, we recommend Harald Johnson's

Feed your substrate into the printer's straight paper path, if available. High resolution and speed are not critical for processes in this book. Specialized, very large-format and flatbed printers are available through service bureaus for special applications requiring high head clearance or other ink technologies.

Tracks made by pizza wheels. Océ Graphics film FCPLS4 is a 4-mil clear film that can be used on printers with pizza wheels for both general printing and for wet transfers. Removing and replacing pizza wheels is not recommended by printer manufacturers, but if you want to try, instructions are on the Internet.

Mastering Digital Printing (Muska and Lipman, 2003), an in-depth introduction to color management, printers, and printing techniques.

Many of the materials used in the first four chapters, which are devoted to basic processes, are common items, readily available. As later chapters progress to more advanced methods, other materials are more specialized, available only from manufacturers or distributors; contact information for those is at the back of the book in "Resources." But for a general review of the basic elements used to create the art presented in this book, let's begin with the major tools.

Printers

Most inkjet printers use either thermal or piezo print heads. Thermal heads have a limited life, but are inexpensive to replace if clogged or damaged. Piezo heads are more accurate and robust; without abuse, they should last the life of the printer. Most of the processes in this book use inkjet printers and will work with desktop printers, but note: The ejection rollers common to desktop printers can cause problems (see "Pizza Wheels," next page).

The Epson Stylus Pro 4000 is the only desktop printer at this time that allows the user to select a "no wheels" option. A large-format printer (24" or wider) definitely expands your options. We recommend pigmented inks, a straight paper path, large cartridges (or a bulk, continuous ink system), and high head clearance so that thicker surfaces can pass through the printer. For all processes, set your printer to its maximum media thickness and highest head height. A straight paper path, which will allow you to print on rigid and semi-rigid surfaces, is accessed by feeding the paper directly into the back of some desktop printers.

PIZZA WHEELS

Most desktop and some large-format printers have wheels, tabs, feet, or rollers (referred to as "pizza wheels") that come in contact with the image immediately after it is printed. Although these mechanisms present no problem on a porous medium like paper, on a nonporous surface like film, the ink briefly wets the inkjet precoat and the rollers that come into contact with the printed image track, or drag, on the surface and damage the print.

Inks

Most inkjet printers use water-based inks, comprised of distilled water, glycol, dyes or pigments, and small amounts of ultraviolet inhibitors and drying agents. The most readily available inks for artists are water-based dye or pigment inkjet. Water-based dye inks are known for their exceptional color range. On the whole, dyes are less permanent than pigments and tend to run and bleed with some processes. Pigments are finely divided solid materials that give pigment inks their longevity. Water-based pigment inks, known for their high resistance to fading, typically have a smaller color range than dye inks.

We recommend pigment inks for the processes in this book that use inkjet printers. However, note that some manufacturers market their inks as "archival," such as the Epson UltraChrome brand, but do not identify them as being pigment. Printer manufacturers match their inks to their printers; beware when using discount inks not made by the printer manufacturer. Although those inks can save you money, their performance may vary, and their use may damage the printer and void the manufacturer's warranty. Carefully research nonmanufacturer discount inks before using them. Other ink technologies (including dye sublimation, UV curable, solvent, phase change, and laser toner) are discussed

The Lyson continuous ink system cartridges, compatible with the Epson 2200 printer, are easy to install and economical to use.

throughout the book, but they play a minor role in most of the processes. If you choose to begin your experiments with dye-based inks, the only processes that will not work are the transfer-based processes.

The traditional inkset consists of cyan, magenta, yellow, black (CMYK), but some manufacturers add colors to expand their ink gamut. Six-color and eight-color ranges add lighter densities of cyan and magenta (LC, LM) or orange, green (O, G) or both.

CONTINUOUS INK SYSTEMS

Inkjet printers have become dramatically cheaper over the last few years, but the inks for them, packaged in small cartridges, are expensive. An alternative is a third-party, bulk, or continuous ink system, which uses tubes to connect larger containers of ink to retrofitted cartridges.

One example is the Cave Paint continuous ink system (CIS) for the Epson 2200, from Lyson, which actually costs much less to use than the same amount of ink from Epson. You can assemble the Lyson system and have it operational in about a half-hour. Its pigment inks are bright and rich without any change in profiles. Lyson makes similar systems for other printers.

Surfaces

Paper, canvas, nonwoven fabric, film, and a host of other materials are the surfaces, or substrates, on which we print images. Once your chosen surface is precoated, as described below, you are limited only by your printer's ability to accommodate the size and thickness of that surface. If the surface is too large or too thick to print on, the image can still be printed on a prepared film, then transferred to your surface. Wood, metal, tile, Plexiglas—almost any flat or three-dimensional material—can be used. The chapters ahead will show you how to select, prepare, and create all kinds of unusual surfaces for your art.

Precoats

To maximize the quality of inkjet printed papers, canvases, films, and other surfaces, manufacturers precoat them. The most predictable matches between printer, ink, and surface (and often the most expensive) are those provided by the printer manufacturer itself. The coating is carefully designed to control the size of the inkjet dot, to adhere the water-based ink to the surface, and to speed drying time. A back coating also helps keep the treated surface flat and stable as it moves through the printer.

There are three kinds of commercially applied precoats: gel, microporous, and white matte. A gel-type precoat feels sticky when pressed with a wet finger and can act like a monoprint release medium, allowing any image printed on it to be transferred to another surface. However, to keep the precoat and your printed image from moving, most manufacturers add an adhesive layer that destroys the precoat's transferability. Microporous precoats, often advertised as "universal," work with most inksets, dry immediately, exhibit no dot-gain, and cannot be used for transfer processes. White matte precoats, usually used on paper or canvas, are water resistant.

Very few do-it-yourself products are sold for preparing surfaces for inkjet printing. A common choice is rabbitskin glue, which has been used by artists for centuries as an adhesive, a binder, a component of gesso, and to "size" canvas and fabric for painting. Offered in granules, sheets, and other forms and in various degrees of purity, each rabbitskin source has its own recipe for preparation. For consistency and availability, we chose the granule form made by Daniel Smith for demonstrating rabbitskin use in this book.

The inkAID brand offers clear gloss and semi-gloss precoats. Because they are clear, they are used for most of the processes in this book. Another of this company's products is a white matte precoat, which goes on milky but dries to a very flat and bright white surface that is water-resistant when printed with pigmented inks. Whichever precoats you choose, testing them first on your substrates before using them for making art is always a good idea.

Postcoats

After printing your image, if you do not frame it under glass or acrylic, you may choose to apply a postcoat to protect it from fingerprints, water, fading, and airborne contaminants. Postcoats may be sprayed, brushed, or silk-screened. For compatibility, choose your postcoat based on the precoat you used. On microporous or gel-type precoats where water-based postcoats might move the inks, use a lacquer or solvent-based product such as Golden MSA (mineral spirit acrylic varnish), ClearJet, or Krylon Crystal Clear spray.

Test postcoats on your materials before applying to finished art. When brushing on a postcoat, you may need to stabilize the surface first with clear spray fixative. Also note that media precoated with calcium carbonate (as in inkAID white matte) are water-resistant, but not resistant

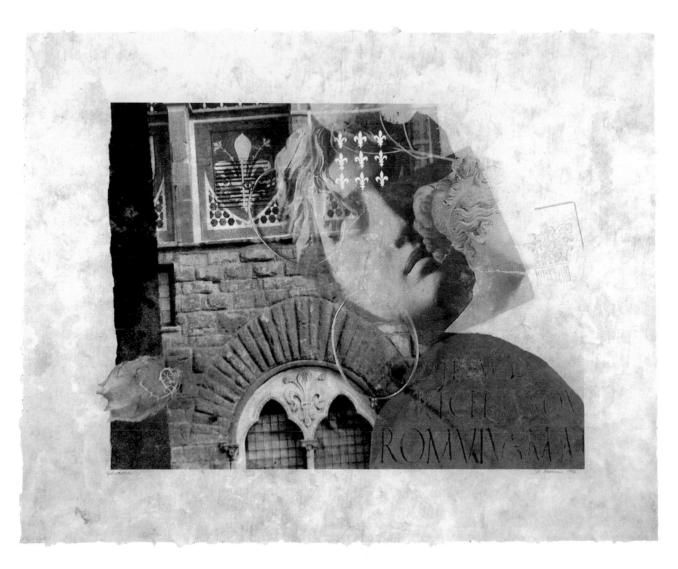

Dorothy Simpson Krause,
EPHEMERA
Service bureau inkjet print
on handmade bark paper,
26 × 32" (66 × 81 cm),
1992.

to common solvents like mineral spirits. Such solvents can dissolve the binder in the substrate's dried coating, which may result in the appearance of gray, streaky dust on the surface of the print. Those streaks may not appear until later, making this problem particularly frustrating and difficult to identify. So for your postcoat with white matte precoat, use ClearShield Type C liquid laminate or an acrylic product like Golden Polymer Varnish.

Drivers and Raster Image Processors (RIPs)

Most desktop printers and some wide-format models allow prints to be made directly from image-editing software like Photoshop. They come with printer-driver software that is simple to install, convenient to use, and usually free. An RIP is software that interfaces between computer and printer to transform the image on the screen to the image on the paper. RIPs provide many more options than drivers, but they can be as expensive as the printers they control. Many wide-format printers require RIP.

Plastics

When using plastics to prepare art, always ask: Will this plastic stay perfectly flat, and will it bond to or release the items I apply to it? Plastic surfaces come in many different forms.

Polypropylene is a translucent or tinted plastic that allows almost nothing to adhere to it. It comes in rigid $1/16"$ sheets or thicker. Trash bags, rolls of landscape sheeting, and painter's drop cloths are sources for flexible sheets of polypropylene. All may be used as a base for building a collage that can be peeled off later.

Polycarbonate is a very hard, clear plastic to which acrylic medium and paint adheres. Sheets as thin as .010 inches can be used as a transparent collage base that remains part of the art.

Acrylic (known mostly as Plexiglas) is less expensive than polycarbonate, but is not sold in such thin sheets. Acrylic can be distressed, coated, and used to make opaque or transparent layered images. When framing prints, artists often use acrylic instead of glass.

Polyester film is the most widely used base for commercially coated inkjet clear and white film. Océ FCPLS4 and Kimoto SC4 Silkjet are two brands that will fully release the ink so it can be used for transfer processes. Dura-Lar, an uncoated polyester film, is readily available, inexpensive, and will release hand-applied inkjet precoats. PetG is another high-quality polyester film.

Spun-bonded nonwoven synthetic fabrics are used extensively in preparing customized surfaces. Unlike canvas or paper, they will not warp, shrink, or stretch when wet; they remain flat, and other media applied to them will adhere permanently. Spun-bonded polyester, for clothing interfacing, is sold under various trade names in fabric stores; spun-bonded polypropylene, a gray landscaping material, is also available. These fabrics may prove to be the high-tech, customizable canvases of the future.

Acetate, the transparent film used with overhead projectors, is not suitable as a transfer film, but it might be used as a base for small collages, and is widely available in letter size.

Glues

Many specialized glues and adhesives serve a wide variety of bonding, sizing, and coating purposes. Here are some of the most useful kinds.

Rabbitskin glue, introduced above as a favored precoat substance, is made from animal collagen. When soaked, heated, and applied warm, it works with any porous material, is very flexible, but expands and contracts with atmospheric moisture.

Methylcellulose, a plant-based starch paste, is prepared by adding water to soften and dissolve the organic material. Wallpaper paste and wheat paste are two common examples; higher quality alternatives are found in bookbinding and art-supply stores. YES glue is a premixed brand of methylcellulose—a paste glue-stick in a jar. It can be thinned with water, will not cause paper to wrinkle, and also bonds paper to other materials, including metal and glass.

Polyvinyl acetates (PVA) glues are perhaps the most common adhesives. Elmer's is a popular version; other high-quality white glues are the Sobo and Jade brands. PVA may be mixed with methylcellulose to give it additional strength and flexibility.

Spray adhesives, such as 3M 77, are very strong and dry clear. They require ventilation and a protected area (like a cardboard box) to contain their overspray fumes.

Acrylic mediums are good both as adhesives and for surface texturing. Thicker gel mediums have the most binding properties. All acrylic mediums are archival.

Adhesive laminate in clear sheets can invisibly glue together two transparent surfaces like Plexiglas and clear film. Such laminates are best applied under pressure.

Permanence and Safety Factors

WE USE ONLY PIGMENT INKS in our work because they have a higher permanence rating. When choosing surfaces and other materials, be aware that some choices may affect the potential life of your artwork. This is true with all mixed-media art, but even artists who use newspaper—or even butter, peat moss, or river water—still want their creations to last as long as possible, to be "permanent," or archival. While a medium such as watercolor or photography may have a limited life expectancy, in fact, early digital prints shifted color or faded in only days or weeks. However, since the advent of inkjet pigment inks, the longevity of digital prints has improved dramatically. The inkset, substrate, postcoating, and environmental conditions—light, moisture, temperature, contaminants—all interact to affect the life of a print.

Materials Safety and Data Sheets are available upon request from most manufacturers of the materials used in this book. Consult those guidelines for product-specific warnings. However, the processes described in this book present no known health hazards when used as directed. Some processes were even developed as nontoxic alternatives to traditional methods. Wear protective gloves while working and cleaning up.

Finally, protecting your work surface with newspaper or a drop cloth is a great time-saver when cleaning up. Between work sessions, be sure to keep your materials closed and away from food, children, and animals.

And now, we invite you to experiment, explore, and enjoy!

Bonny Pierce Lhotka
TREELINE
Inkjet print on distressed Plexiglas, 40 × 30" (202 × 76 cm), 2003.

Part One
Basic Processes

THE FIRST FOUR CHAPTERS of our book discuss how to choose a commercially precoated surface for inkjet printing; how to create your own surfaces; and how to integrate your favorite art materials with images from your inkjet printer through underprinting or overprinting methods. These basic processes are the foundation for the more advanced methods covered in the second part of the book.

LEFT: **Karin Schminke**
LOCUST IN SPRING
Inkjet print on rice paper overlaid on buff-colored paper, 12 × 8¹/₂"
(31 × 21 cm), 2003.

OPPOSITE: **Dorothy Simpson Krause**
REFLECTIONS
Inkjet print on custom precoated aluminum, 24 × 24" (61 × 61 cm), 2003.

Choosing Printing Surfaces

YOUR ARTWORK STARTS with your surface, also known as the "substrate." In traditional digital printing, the substrate is merely meant to hold the printed image. But when digital printing combines with a traditional art medium, the surface becomes more important. In some cases, it can be as important to your artwork as the images you print on it.

You can choose surfaces specifically precoated for inkjet printing; you can experiment with standard fine-art papers; or you can precoat uncoated surfaces. This chapter discusses all three options.

The affinity between the surface on which the print is made and the ink determines the success of the print. If the surface absorbs no ink (as in aluminum foil), the ink will puddle and run; if it absorbs too much ink (as in newsprint), the images will appear desaturated and flat. The ideal choice has low absorbency, causing most of the ink to sit near the surface. This ink "hold-out" is the key to sharp details and bright colors in your print.

To create ink hold-out, you must treat papers and other printable surfaces before use. Traditional art papers are "sized" so that they retain drawing ink without bleeding. Various substances are added to the paper stock in its pulp state to help the paper resist liquid penetration. You can also coat the paper's surface with these same kinds of substances to control its absorbency further.

Many products are now specifically precoated to receive prints from inkjet printers. In addition to all kinds of papers, there are canvas, vellum, and an assortment of specialty surfaces such as metallics. These products offer good color range and excellent ink hold-out, giving immediate success to the novice printer. Many artists find that commercially coated canvases work well for their art; they like the extra texture provided by the canvases, as well as their ease of use.

Bonny Pierce Lhotka
DELICIOUS (DETAIL)
Inkjet print on found cloth
with acrylic paint, 24 × 24"
(61 × 61 cm), 1992.

Commercially Precoated Surfaces

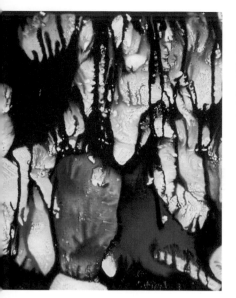

Printing on untreated, nonabsorbent material like this plastic sheet causes the ink to run.

Untreated newsprint is too absorbent, producing a soft, dull print.

READY-MADE SUBSTRATES have many advantages: They require no preparation; they produce predictable, consistent results over long periods of time (more so than with do-it-yourself precoats), a particular asset when printing editions; and they are designed to work with specific ink sets for "perfect" prints every time. Some traditional artists find this last "advantage" problematic. The resultant images may seem too sterile, lacking a sense of the artist's hand at work. In addition, ready-made surfaces are more costly than coating your own. You may also want a wider choice of products. Although the range of commercial precoated surfaces does continue to expand, items may be changed or discontinued, leaving you in a lurch.

Having said all that, ready-made products are useful as a starting point for many of the processes discussed in this book. They are also useful for obtaining a quick color proof to help you develop a composition, and for showing sketches to obtain commissions before developing your own mixed-media surfaces. A good resource for ready-made surfaces is your printer manufacturer. Each firm has a line of materials matched to its own printer and inks, all but guaranteed to give you good results. These surfaces come in boxed sheets sized for desktop printers, and rolls or sheets sized for larger printers and usually are coated on one side only, so be careful to print on that side. The coated surface is the outside of the roll; with sheets, it may be harder to identify, but most boxes indicate which side is printable. A small pencil mark on the back side of the paper as you take it from the box may prevent later confusion. To create a water-resistant print, if that characteristic isn't listed on the manufacturer's box, check with the supplier before purchasing that precoated product.

Commercially treated fine-art paper gives this print its sharper, brighter image.

INTERESTINGLY, some off-the-shelf papers from your local art store can be printed on with satisfactory results (of course, your success may depend on how you define "satisfactory"). But fine-art papers are worth exploring and often produce beautiful images, although when papers are not designed to be used as inkjet papers, the ink hold-out can be very low and absorbency very high, resulting in images with a softer focus and duller color than those printed on properly prepared surfaces.

You can partially compensate for such dullness by increasing the saturation and brightness or printing at higher resolution to increase the ink load. Some printer software allows for overprinting or increased ink densities. This feature is even more likely to be found in raster image processing (RIP) software, which has more options for printer control. But these compensation methods can be difficult to control, so it's best to select papers with the most ink hold-out.

Papers with lots of sizing and/or a hard surface have greater ink hold-out than more absorbent, soft, or fuzzy papers. If available, papers that have both surface sizing and internal sizing are preferable. The Daniel Smith catalog gives sizing information for various papers. Select hot-pressed papers over cold-pressed for their greater smoothness.

You can successfully print on the following art papers: silk tissue paper, the brands Daphne, Lanaquarelle, and some Japanese papers. Lanaquarelle is a great choice because it is available in smooth, hot-pressed form with both internal and surface sizing. Be aware that some of the thinner papers may not have enough stiffness to feed through your printer. Artists with smaller desktop printers often iron thinner papers onto waxed or freezer paper prior to printing in order to stiffen them.

Unsized or "waterleaf" papers (Arches 88, Twinrocker Feather) have no sizing and thus absorb water like a paper towel. They are difficult to print to, but perfect for transferring to without a press. In a later chapter, we will take advantage of this unique characteristic to make wet transfers.

The same picture printed on untreated watercolor paper (left) and on commercially precoated watercolor paper (right), has a richer, more detailed image on the treated surface.

The first of these two prints (left) was made on Tableau, a brand of uncoated, acid-free hemp paper; the second (right), was saturated in Photoshop to increase color intensity, and printed on identical paper.

Dorothy Simpson Krause
CHINATOWN
Inkjet print on untreated Nepalese
lotka-fiber paper, 22 × 30"
(56 × 76 cm), 1998.

Bonny Pierce Lhotka
SHELTER
Inkjet print on untreated 300-lb
watercolor paper, 26 × 24"
(66 × 61 cm), 2003.

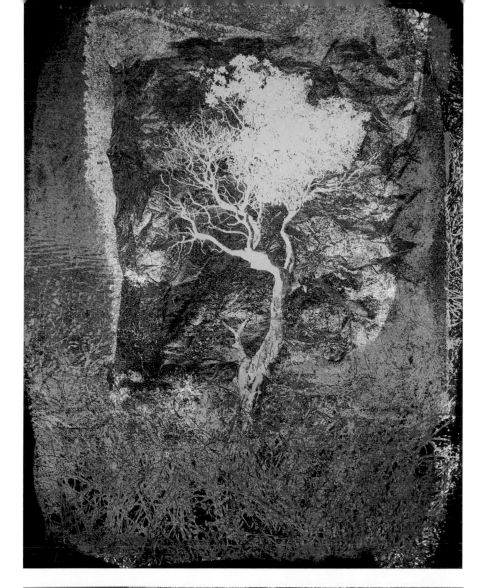

Karin Schminke,
AQUATANIA
Inkjet print on commercially precoated
140-lb watercolor paper. 36 × 28"
(92 × 71 cm), 2003.

Karin Schminke
FOOL'S GOLD
Inkjet print on commercially coated canvas,
4 × 4' (256 × 256 cm), 2002.

Precoating Your Own Surfaces

A slot ruler is an easy-to-make tool to help you build customized printing surfaces that avoid head strikes. Place coins equal to your printer's clearance at the ends of two square aluminum tubes, and secure them in place with duct tape. Slide your substrate through to check for high spots before printing. Printers that will accept mat board have 1.5mm clearance, the thickness of a new penny.

A Fome-Cor (lightweight laminated board) tray holds these precoated ceramic tiles as they are printed in an Encad 880 flexible media printer.

BELOW: **Bonny Pierce Lhotka**
INNOCENCE
Inkjet print on 2" ceramic tiles treated with white matte precoat, 24 × 24" (61 × 61 cm), 2002.

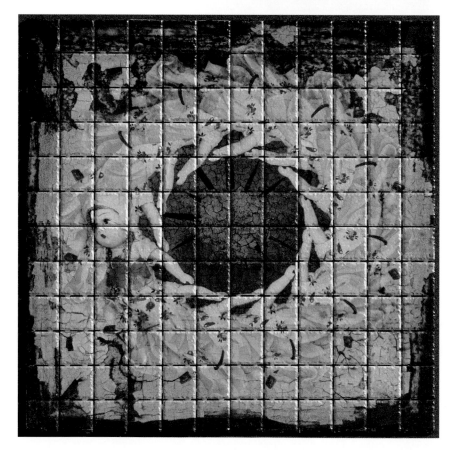

ALTHOUGH YOU MAY LIKE the dependability of precoated paper or the soft look of printing on uncoated fine-art paper, eventually, you may want your images to be more unique or have brighter colors. At that point, consider coating your own papers. Like priming a canvas with gesso, precoats assure better color results. In addition, coating your own materials can be a big money saver, and you can transform many nonart materials into printable surfaces. You are only limited by your imagination and what will fit through your printer. Experiment with bark paper, leather, aluminum, Plexiglas, and wood veneer. When coated with an inkjet receiver, as long as those materials do not exceed the thickness recommended by the printer manufacturer, they are usable. Some printers, for example, can print on mat board thickness—so any materials thinner than a mat board (typically 1.5mm) could be precoated and fed through the printer. Just be sure the materials aren't too heavy or uneven.

A flexible media printer like the Encad 880 with extra head clearance opens up many interesting possibilities for printing on more dimensional media. By building a reusable "tray" to hold your substrates as they go through the printer, you can take advantage of most of the printer's half-inch head clearance and keep the print head away from irregular surfaces.

We can hope that more printers will increase head clearance in the future, but currently, the Encad 880 is the most economical choice for flatbed functionality. Some flatbed printers are designed to print on surfaces up to 12" thick; for example, on a stretched canvas, glass, or bricks.

WARNING: If you have a small desktop printer with paper guide "pizza wheels," as described earlier, you can still perform the processes in this chapter with any inkAID or rabbitskin glue, provided the precoat will apply to an absorbent surface such as paper. On a nonabsorbent plastic surface,

use the white matte precoat because the ink dries as it is printed on and won't ruin your printer. Again, make sure your surfaces are thin enough to feed through your printer.

The ability to create your own printable surfaces opens up a whole new world of creative possibilities. During the precoat process, you can even introduce brushstrokes and other textures to the surface itself beneath your print, creating a unique and individualized base for your art.

Precoat Materials

Precoats are not always interchangeable. In this book, we have selected the most appropriate coating for each process, noting any suitable variations.

Just ahead, you will learn how to mix and apply two of the precoats that we recommend: rabbitskin glue and a white matte precoat. Traditionalists are most comfortable with rabbitskin glue, the inexpensive and readily available adhesive that has been valued by artists for centuries. However, you must mix it every time you need it, otherwise it can spoil. Being affected by water and weather, it also varies in quality from batch to batch in ways that can affect your precoating. So if your surface is dampened, it can cause your image to blur. Rabbitskin precoat can also shrink or expand with changes in humidity, causing it to pop off of nonporous surfaces.

White matte and other clear precoats are marketed by inkAID, which offers consistent, ready-made products that are easy to use, although more expensive than rabbitskin glue. The company's white matte precoat is a fine choice for a brilliant white, matte surface. It does a good job of covering colors completely, especially if you use two coats. It is also the choice for small-format printers, since it dries instantly when printed on. There are two clear inkAID products: semigloss and gloss. Both can be applied to absorbent and nonporous surfaces; however,

to apply gloss on a nonporous surface, you must first apply a coat of inkAID adhesive.

Preparing White Matte Precoated Surfaces

Protect your worktable with newspaper, since you will be painting precoats over the edges of your sheets. Better yet, a large sheet of plastic makes a reusable surface that cleans up easily. Wear protective gloves when handling precoat material and when cleaning up afterward. For this exercise, we coat Strathmore Aquarius II synthetic watercolor paper, since it doesn't stretch or shrink when moistened.

MATERIALS
- protective gloves
- newspaper or plastic sheet to protect work surface surface
- matte white by InkAID (recommended for desktop printers)
- sponge brush
- Strathmore Aquarius II 80-lb synthetic, cold-pressed watercolor paper

1 Place paper faceup on a protected surface.
2 Stir white matte precoat and with a sponge brush apply an even coat on your paper. One coat will often suffice, but to get the richest colors and to ensure that you've covered the sheet perfectly, you may apply a second coat after the first has dried thoroughly (usually overnight). Clean up with soap and water.
3 After the surface is "set up" and no longer runny, hang the sheet from one end to reduce wrinkling of the paper.
4 Wait until the precoat is completely dry. Check to see that your paper is flat enough to feed through your printer without the printer heads striking or dragging on the paper.
5 When dry and flat, feed into printer and print normally.

MANY PAPERS (both precoated inkjet and uncoated fine-art) come with beautiful deckle edges. If you want these to be part of your art, frame your print with a "float" mount, in which the paper is hinged on a backing board so that a mat does not hide the paper's edges.

STEP 1 Using $1/2$" drafting tape, lay your paper facedown on a table. Tape the paper's edges to the table with half the width of the tape covering the paper's edges and the remaining tape width sticking to the table.

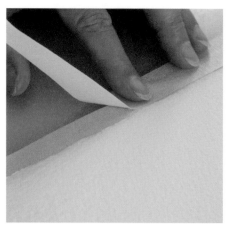

STEP 2 Lift paper and tape from table by pulling on tape corner. Don't pull paper; it may leave tape behind. Turn paper over with front side and sticky side of tape faceup; retape to table. Cover original tape ($1/4$" should show) with half the width of new tape; let remaining half stick to table. Don't cover paper edges; only tape onto original tape and table.

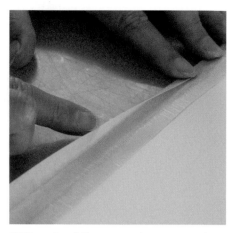

STEP 3 Carefully remove the paper and tape from the table by peeling and pulling on a corner of the tape, not the paper. Turn the whole thing over and fold the sticky edge of the new tape over to create a $1/4$"-wide tape edge.

STEP 4 Repeat steps 1–3 for the top and bottom of the paper. Be sure to run the top and bottom tape to the edges of the side tape, since corner strength is particularly important.

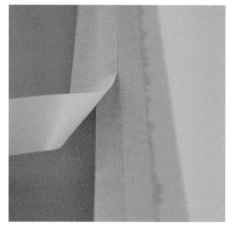

STEP 5 You may need a longer edge for the printer to grip, either for smooth feeding or to accommodate your printer's minimum margins—the leading or trailing edge of the paper as it feeds through the printer. (See your printer's documentation for details.) To create a longer edge, add a third length of tape to the edge you want to increase by repeating steps 2 and 3, which will give you a $1/2$"-wide taped edge.

STEP 6 Trim any excess tape to create square corners. If the corners that load into the printer first are not stiff, add a small piece of tape to reinforce the edge where the two tapes meet. When your new "extended" paper is complete, measure and note its size. You will need to know its dimensions in order to print your image precisely on your paper. Also measure the size of your tape margins.

WHEN YOU CREATE your image size, make sure it is larger than your paper by ¹/₄" to ¹/₂" in width and height, to allow placing the image so it prints into the taped edges, covering your substrate completely.

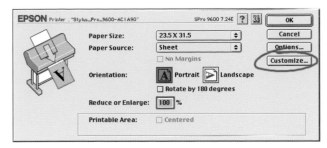

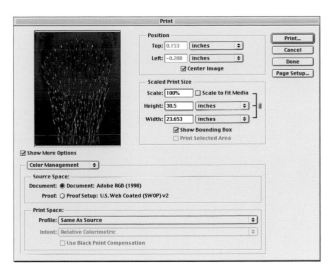

STEP 1 In Photoshop's "Print Setup" dialog box, click on the "Customize" button to create a sheet exactly the size of your paper (as measured in the final step of the previous demonstration).

STEP 2 In Photoshop's "Print" dialog box, specify the position that your image will have on your paper. Enter the margins for your printed image in the "Position" fields, or leave the "Center Image" button checked.

STEP 3 Print your image, which extends onto the tape. If this is your final printing process, remove the tape. If you plan on adding other processes to your paper, wait until all printing is finished before removing the tape.

Karin Schminke
MAGIC
Inkjet print on 300-lb cold-pressed paper, 30 × 22"
(76 × 56 cm), 2003.

CHAPTER 1: CHOOSING PRINTING SURFACES

Mixing Rabbitskin Glue

Rabbitskin glue inkjet receiver is for precoating paper and other surfaces. It can also be used as a glue to assemble collages. Once mixed, rabbitskin glue does not keep and it cannot be reheated, so make only the amount you need. Just half the recipe presented here, for one cup, will coat several sheets of 22-×-30" paper.

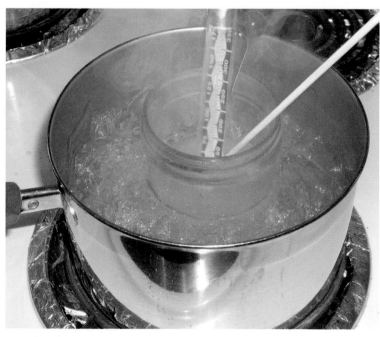

These are the materials for mixing rabbitskin glue.

A glass jar in a pot makes a good improvised double boiler.

MATERIALS

- protective gloves
- newspaper or plastic sheet to protect work surface
- 2 level tablespoons of Daniel Smith rabbitskin glue granules
- 1 cup cold water
- double boiler
- spoon or stirring stick
- candy thermometer

1 To make 1 cup of rabbitskin glue, sprinkle 2 level tablespoons of granules into $1/2$ cup of cold water.
2 Stir, then let it sit for 15 minutes until the granules swell and look like applesauce. Stir in the other $1/2$ cup cold water.
3 Place the container in a double boiler and heat to 145 degrees and maintain that temperature for 15 minutes. Since the temperature must be maintained at a constant 145 degrees, and higher temperatures will damage adhesive properties, do not use a microwave.
4 Let the glue cool to 75–100 degrees before using. If hotter, it may shrink, causing a nonporous surface like plastic to curl.
5 Discard any unused cooled glue. Reheating the glue reduces its adhesive properties, and storing the glue causes it to mold and rot.

Preparing Rabbitskin-Glue Precoated Surfaces

As noted earlier, since rabbitskin glue can't be reheated, make only the amount needed for a particular project. However,

when a second coat is called for in preparing your printing surface, as in this exercise, keep part of your mixed batch of rabbitskin glue warm. Just wrap your jar of warm glue in a towel and place it in an insulated lunch container, or store it in a soup thermos. (Of course, once your thermos has contained glue, it should never be used again for food.)

MATERIALS
- protective gloves
- newspaper or plastic sheet to protect work surface
- batch of mixed rabbitskin glue at 75 degrees
- bristle brush
- Strathmore Aquarius II 80-lb cold-pressed, synthetic watercolor paper

1 Cover your table with newspaper or plastic sheet.
2 With a bristle brush, apply an even coat of glue to your paper. Use parallel uniform brushstrokes across the entire surface. Flatten paper after each coat. Apply the second coat only after the first has dried thoroughly. Brush it on with strokes perpendicular to the first coat.
3 When the glue is dry to the touch, feed the precoated paper into your printer and print normally.

Flattening Paper After Precoating

Moisture in the precoating process can curl paper, so if your coated sheet won't lay flat on a table, hang it by one corner as soon as it's dry enough not to drip. Let it dry overnight. If the paper is still too curled, press it flat under a heavy board overnight. Large sheets to be fed through large-format printers can be formed into a soft roll (6" diameter or larger, with precoated side out), and that will often even out bumps in the paper in 5–10 minutes so that it feeds easily through the printer. To flatten very thin paper, press with a laundry iron—a sheet placed on the paper to protect its surface. Finally, if you have access to a cold laminator or an etching press, put curled paper through the press to flatten it.

To flatten paper that curled during the precoating process, hang it by one corner when dry enough not to drip.

To flatten out lumps in large paper, roll it with the precoated side out.

What's Next

Whether you choose to print on commercially prepared surfaces, fine-art papers, or on your own precoated surfaces depends on the effect you wish to achieve and the amount of time and energy you are willing to spend on your project. In the next chapter, we explore ways to create your own customized substrates. Rather than merely preparing standard art surfaces, you will actually learn how to create unique, nonstandard surfaces that add to the richness of your mixed-media art.

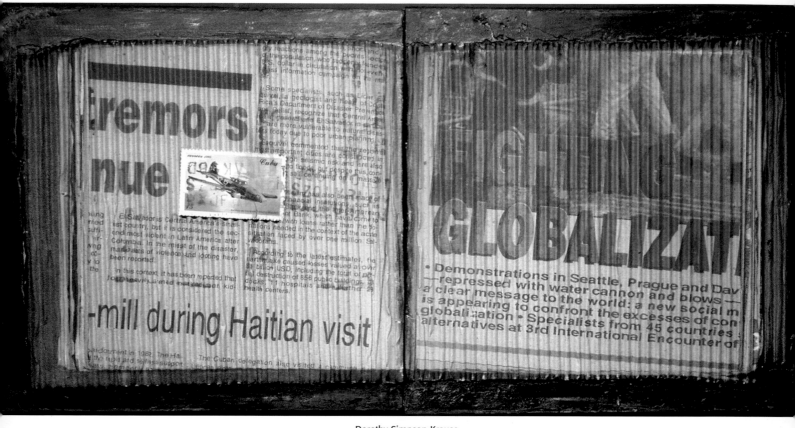

Dorothy Simpson Krause
FIGHTING GLOBALIZATION
Inkjet print on corrugated cardboard, (diptych) 12 × 24" (31 × 61 cm), 2001.

OPPOSITE: **Bonny Pierce Lhotka**
PAPER PULP
Inkjet transfer to handmade paper, 30 × 24"
(76 × 61 cm), 1998.

CHAPTER 1: CHOOSING PRINTING SURFACES

Creating Customized Surfaces

IN THIS CHAPTER, we move beyond conventional fine-art surfaces and into the more varied world of handmade supports, a component that enhances and interacts with your art and the materials you place on it. With customized surfaces, your making of art begins well before printing.

Any surface able to pass through your printer can be prepared with a precoat for printing. There are numerous ways to precoat surfaces, making their creation an exciting area of artistic exploration. We will focus on the three major ways to create customized surfaces: the Base Method, the Carrier Method, and the Support Method. Each has its own advantages and characteristics, which will be discussed in the various projects that follow. But first, to define each process briefly:

The Base Method, aptly named, builds on a base, or surface, which becomes a foundation for the art.

The Carrier Method employs a plastic sheet that carries, or accompanies, the paper to be printed through the printer, then releases the paper after printing.

The Support Method entails building a surface on a support, or temporary base, removing it from the support, then flipping it over to expose a glass-smooth surface for precoating and printing.

The first of two processes for you to try that makes use of the Base Method is preparing linen canvas to be used as a printing surface for your art. Although there are inkjet-precoated canvases made of cotton, precoated linen canvases are currently unavailable; this process fills that gap. The naturally irregular character of linen fiber can bring a visual richness to your art that commercially available canvases can't match. Because linen (and other woven fabrics) stretch and shrink when wet, they must be stretched before applying the gesso and precoat, and cut from the stretchers when dry. Details of that procedure will be given in the instructions ahead.

The second Base Method for you to consider is the preparation of nonwoven "canvas." Once a precoat is applied to it, nonwoven fabrics will feed easily through most printers, as they do not warp when wet, providing another unusual customized surface for your artwork.

Karin Schminke
FIVE DANAEDIA
Inkjet print over Kwikprint photo emulsion and acrylic paint on 100-percent cotton printmaking paper, 43 1/2 × 30" (110 × 76 cm), 1996.

MATERIALS

- protective gloves
- newspaper or plastic sheet to protect work surface
- unprimed linen canvas
- X-Acto knife or single-edged razor
- metal-edged ruler
- heavy-duty stretcher bars
- plastic wrap
- gesso
- scraper made of plastic (such as a credit card), metal, or stiff cardboard
- sandpaper
- inkAID white matte precoat
- clear postcoat spray sealer
- staple gun or hammer and tacks
- final, traditional stretcher bars

SELECT AN UNPRIMED linen canvas of 6–10 ounces that has a thread large enough to allow the weave to show through, even after you have applied all the coatings. Assemble the other items listed, and be sure to wear protective gloves while you work.

STEP 1 Using unprimed linen canvas (the wider weave will show through coatings more clearly), cut the linen 12" wider and longer than the image to be printed. On each side, you will lose 3" in the preparation and have 3" remaining for restretching after the image has been printed.

STEP 2 Choose heavy-duty stretchers to allow for linen shrinkage, which can warp lightweight stretchers. Bars should be 6" larger than the image so you can cut the canvas from them later and restretch it on conventional bars. Cover stretchers with plastic to protect the linen if gesso seeps through the fabric; stretch and staple or tack the linen on the plastic-covered bars.

STEP 3 Apply a coat of gesso with a scraper; let it dry, then apply a second coat. If diluted, some gessoes crack over time, so read gesso label for instructions; when in doubt, apply undiluted. Lightly sand the surface after it is dry. Apply a coat of white matte precoat and let it dry; then apply a second coat.

STEP 4 After the primed, coated canvas has dried for at least twenty-four hours, trim the canvas off the front of the stretcher; if it is not trimmed perfectly square, retrim the edges with a very sharp blade. Remember, the print head will strike distorted edges, so handle the canvas carefully. Print your image centered on the canvas; let it dry thoroughly. Spray with a clear postcoat sealer. Staple or tack the finished work on traditional stretcher bars.

Creative Explorations

- To bring added interest to a customized canvas surface, use Liquitex transparent gesso on part of the linen to let the natural color show through in selected areas of your digital print. Then apply gloss or semi-gloss clear precoat or rabbitskin glue.
- Another way to give a glow to your finished print is to put a coat of pearl pigment over the gesso, followed by a precoat of clear gloss, semi-gloss, or rabbitskin glue.

TIPS

- Overstretching printed canvas can cause the image to crack. For large canvases, attach a rigid support like untempered Masonite to the front of the stretcher bars. After printing, adhere the canvas to the support to prevent cracking, then staple the sides to the bars.
- If you don't print immediately, roll your prepared canvas face out onto a 4" tube with a covering of butcher paper to protect the surface.

Bonny Pierce Lhotka
IN THE WOODS
Inkjet print on custom-precoated linen canvas, 26 × 24"
(66 × 61 cm), 2003.

MATERIALS

- protective gloves
- newspaper or plastic sheet to protect work surface
- nonwoven fabric (spun-bonded polyester or polypropylene)
- soapy water in spray bottle
- molding paste
- scraper made of plastic (such as a credit card), metal, or stiff cardboard
- sponge brush
- inkAID white matte precoat

TIP

- If you are unhappy with a print you've made, you can save the substrate by washing off the print and its precoat with water. Let the substrate dry before precoating again. However, if you used white matte precoat, it can't be washed off, but you should be able to recoat the surface by applying more layers of the precoat.

SPUN-BONDED NONWOVEN materials made of polyester or polypropylene can be used as a base for creating a customized printing surface. A nonwoven fabric will not curl or warp and can be textured with a heavy-bodied acrylic gel medium, paper, and varied collage materials.

Prepare nonwoven fabric for the printer by applying a white matte precoat. If you keep your additions close to the surface, the nonwoven fabric will feed easily through most printers, especially if you use a straight paper path.

WARNING: For desktop printers, be sure to use white matte precoat on any variations to the following process, to avoid pizza-wheel tracks.

STEP 1 Break the fabric's surface tension by misting it with soapy water. Then, with a plastic scraper, work a coat of molding paste into the fibers to create a bonding surface for the precoat.

STEP 2 Be sure that ridges or peaks don't exceed the printer's clearance. Press down to remove problem areas. When the surface is thoroughly dry, use a sponge brush to cover it with white matte precoat.

STEP 3 Let the surface dry overnight before printing, as in this example of treated and dried polyester.

Creative Explorations

- To create a transparent substrate, start with a sheet of clear plastic or polyester film.
- Use the acrylic gel medium as a glue to collage paper and fabric to the surface.
- Experiment with a variety of materials—sponge, foil, folded cloth, plastic bag, bubble wrap, combs—to create interesting textures. Paint a coat of acrylic gel medium to texture into, and/or dip the texturing materials into the medium and pat them on the surface.
- Paint on the surface with metallic, pearlescent, or interference pigments, and apply a clear precoat to give a glow or a color shift to the final printed piece.
- Use pumice, sand, or glass-bead pellets to add texture to a surface.
 WARNING: This last tip will not work with pizza wheels.

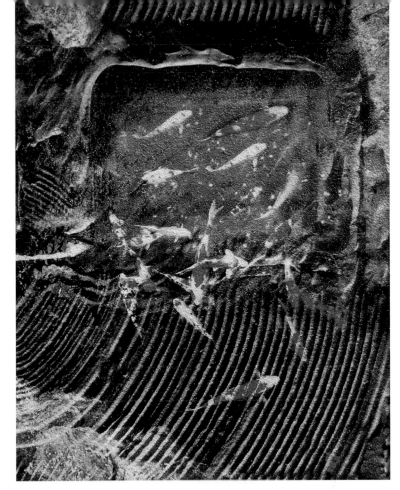

ABOVE: **Bonny Pierce Lhotka**
BASIN
Inkjet print on silica sand mixed with acrylic medium applied to nonwoven fabric, 32 × 24" (81 × 61 cm), 2002.

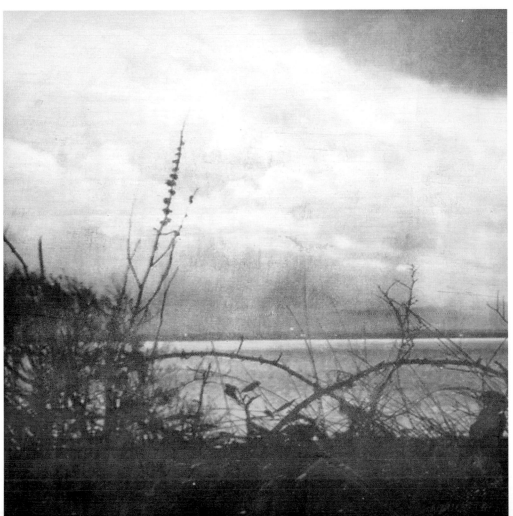

Dorothy Simpson Krause
THORNS
Inkjet print on lightly textured nonwoven fabric, 24 × 24" (61 × 61 cm), 2000.

MATERIALS

- protective gloves
- newspaper or plastic sheet to protect work surface
- thin paper such as Thai Unryu or rice paper
- Dura-Lar polyester carrier sheet
- inkAID clear semi-gloss precoat
- sponge brush

THE CARRIER METHOD is ideal for printing on thin surfaces, such as rice paper or Thai Unryu, which either do not feed well through the printer or do not have a surface able to receive a print. Our carrier demonstration uses a polyester sheet to help your desired paper through the printer, then releases the paper easily after printing. If your printer won't recognize a clear material, use matte polyester or simply place white paper under your sheet of clear polyester.

After cutting your thin paper to desired size, cut your polyester carrier sheet to fit through your printer's path. (With a large-format printer or other without pizza wheels, you can print over the paper's edges by making the carrier sheet about an inch larger than your thin paper; for a desktop printer with pizza wheels, or to print within the paper's border, cut your paper and carrier sheet to the same size.) Position the paper on the carrier sheet.

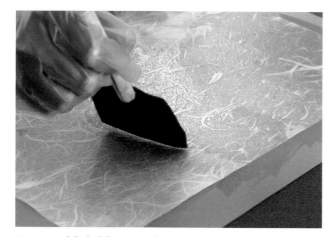

STEP 1 While holding your thin paper in position with one hand, apply the precoat with a sponge brush. The paper will adhere into position quickly. Work outward from your original painted area, brushing a medium thickness of the precoat until the entire paper is covered. Translucent papers become more transparent as the precoat is brushed on.

STEP 2 Allow the precoat to dry thoroughly. If the carrier sheet itself wants to curl, tape its edges to your table so that the thin paper will dry flat.

STEP 3 In Photoshop's Page Setup window, type in the top and left margins in the print box to position your print. For large-format printers: Measure the carrier sheet, paper, and margins between the two. Use software controls to position your image over the paper; you may overprint the paper's edges to get a full-bleed image. For desktop printers: If the carrier and paper are not the same size, either trim the carrier to the size of the paper, or remove all precoat from the sheet around the paper with a damp cloth. With the second option, be aware that ink printed outside the paper will pool on the carrier and may run. With desktop printers, normally you can't print on polyester treated with clear precoat without damaging the print and/or printer, but in this case, the paper area is porous and should work if the precoat isn't so thick that it has a glossy finish.

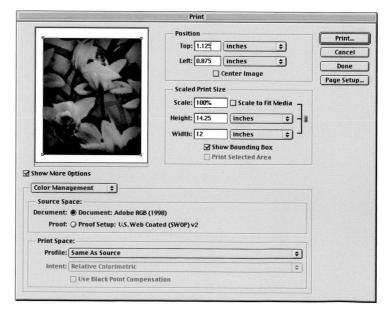

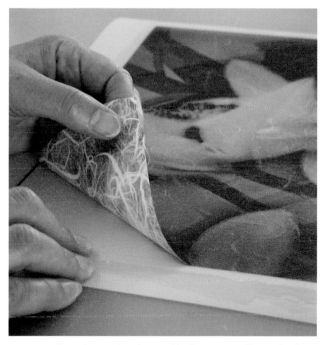

STEP 4 Place the carrier sheet with the paper still attached into your printer and print. Remove the printed paper from the carrier sheet by peeling it off from one corner.

■ To center your paper on the carrier sheet so that its edges may be overprinted: Cut the carrier sheet, then print directly on it a rectangle the size of the final image you want to print. It should be transparent except for a one-pixel black border to mark its edges. Note print-setup settings so you can use them for the final print. This printed border will be damp and blurry, so mark the corners of the rectangle with tape and then wipe off any excess ink before proceeding.

Use the marked corners to position your paper on the carrier so that the print lands properly.

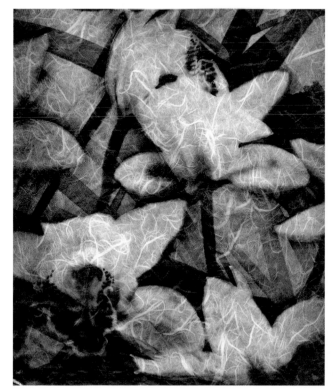

Karin Schminke
ORCHID
Inkjet print on custom precoated Thai Unryu paper, 10 × 8 1/2" (25 × 21 cm), 2003.

Working with transparent papers often results in prints that are equally interesting on the front (left) and back (right).

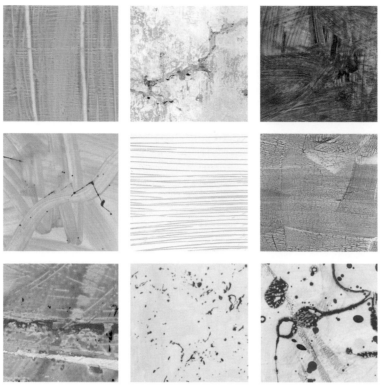

These nine examples of handmade surfaces were prepared using one of the methods—Base, Carrier, or Support—that convert unusual materials, such as canvas, rice paper, and plastic, into substrates for inkjet printing.

Creative Explorations

- Once you've made your first print, flip the paper over, invert the image in your digital file (or choose a complementary image), and repeat the above carrier process to print on the back of the paper. This creates an interesting effect on papers of varying densities and on papers with threads, leaves, and similar components.

- Crinkle thin paper after printing and use it as a unique collage material.

- Many artists experiment with ironing fabric onto waxed paper. This variation of the carrier method is good for small pieces of fabric that you intend to reuse in a collage. Precoating improves the density of the ink and works well for all fabrics, regardless of the carrier employed. However, precoating does stiffen fabric, so its application is not appropriate where the fabric needs to flow naturally, as in wearables. (See additional information on fabrics in Chapter 10.)

A print on thin silk tissue paper overlaying the edge of another print shows the transparency that can result from the carrier method.

THE SUPPORT METHOD uses a rigid plastic (polypropylene) sheet as a support during the construction of a glass-smooth substrate, which is built facedown with layers of clear acrylic medium, tarlatan (starched cheesecloth), and other materials. The acrylic acts as a transparent glue to hold everything flat while allowing the materials to be visible. Once dry, the entire construction is removed from the plastic support sheet and turned over for precoating and printing.

Wearing protective gloves, clean a sheet of polypropylene with vinegar or rubbing alcohol, rinse, and wipe dry. In assembling your other materials, note that Liquitex is the recommended gesso; other brands, not as chalky when dry, may jam your printer.

STEP 1 Pour and evenly spread acrylic gloss medium on the plastic sheet. Let it dry.

MATERIALS

- newspaper or plastic sheet to protect work surface
- rigid polypropylene sheet
- vinegar or rubbing alcohol
- acrylic gloss medium
- scraper tool or other plastic (such as a credit card), metal, or stiff cardboard
- tarlatan (starched cheesecloth)
- X-Acto knife or single-edged razor blade
- bristle brush
- Liquitex gesso
- semi-gloss precoat

STEP 2 Apply a second coat of acrylic medium and allow it to dry. Add paint, comb through wet paint to create a pattern, or add decorative elements that you wish to have appear on the surface when it is removed from the support. Before the paint starts to dry, smooth out any ridges or bumps that might strike the head during printing

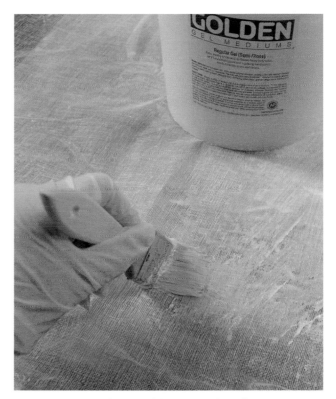

STEP 3 To give stiffness and support to the substrate you are building, cut a piece of tarlatan slightly larger than your plastic sheet. Using a bristle brush, glue the tarlatan to the sheet with acrylic gloss medium, working it into the tarlatan fibers. Let it dry.

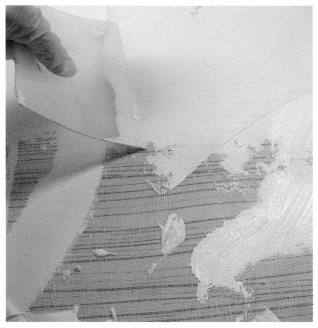

STEP 4 Spread full-strength, undiluted gesso over the tarlatan with a scraper or plastic card. Let dry. If your plastic sheet is over 16 × 20", add a second layer of tarlatan after the first is dry, to provide extra strength, then let the sheet dry completely.

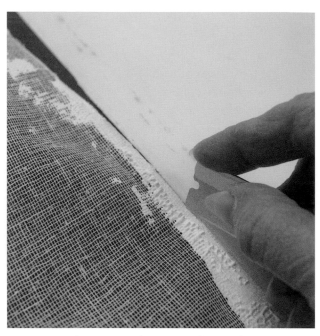

STEP 5 Trim the excess tarlatan from all four edges.

STEP 6 Trim a second time, 1/16" inside the edge. This will allow the printing surface to release neatly from the support sheet, without damaging it for future use.

STEP 7 Remove the substrate by gently pulling it off the polypropylene support. The substrate will be pliable. Turn it over so that the smooth side that was against the polypropylene is now facing up. Coat it with clear semi-gloss precoat, and let it dry before printing.

Creative Explorations

- Adding unusual materials to your printing surface can create appealing effects. For example: Soak a piece of muslin in vinegar, then wrap nails, barbed wire, or other steel objects in it, and let them sit overnight. In the morning, the objects' shapes will be rusted against the muslin, producing interesting patterns.
- Add the whole cloth to your substrate or cut it into small pieces for a collage. This "rusty muslin" technique may be applied during the texturing stages of all methods presented in this chapter.

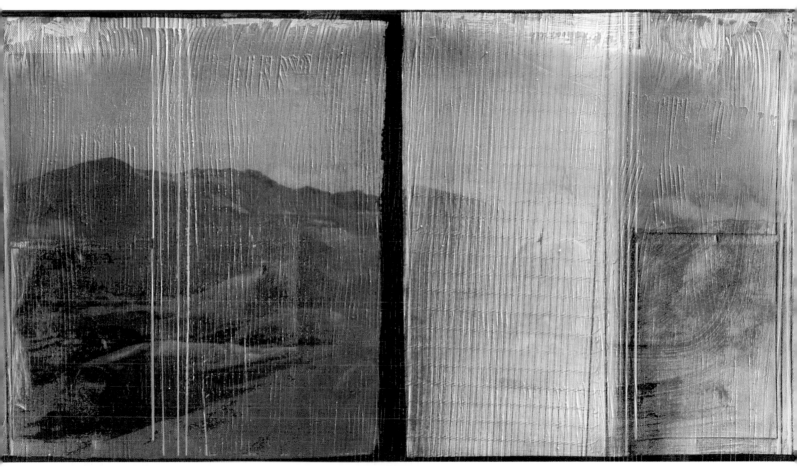

Bonny Pierce Lhotka
GRAYS PEAK
Inkjet print on textured acrylic substrate which was created on a polypropylene support, 12 × 24" (31 × 61 cm), 2003.

What's Next

Whichever method you use—Base, Carrier, or Support—your creative options are greatly increased when you begin with a customized surface.

Now that you know how to prepare unique surfaces, the next two chapters will show you how to print on them, using two different approaches: underprinting on the substrate first, then adding traditional art media on top of the print; and overprinting, by applying art materials first, then printing on top of them.

Dorothy Simpson Krause
FLINT
Inkjet print on heavily
textured nonwoven fabric,
34 × 47" (85 × 120 cm),
2000.

TIPS

- If your printer needs a margin on the edge that goes into the printer first, tape your printing surface to a thin sheet of Dura-Lar plastic, which will also keep the back of the substrate from sticking to the printer and protect the beautiful, uneven, decklelike edges that often result from this process.
- If you decide not to attach your surface to a plastic carrier, paint the back of it with undiluted chalky gesso, which will keep the back from becoming gummy and sticking to your printer's feeding mechanisms.
- It's important to cut the corners square when removing a substrate from a support sheet, so it will feed correctly through the printer. However, X-Acto knife cuts will score a plastic support permanently, and those cuts will show on your next printing surface. To avoid that, always cut off your substrate within $^1/_{16}$" of the edge of the support sheet. Once removed from that sheet, never attempt to trim the substrate, which is fragile and may be damaged.

To store customized surfaces before printing, roll them on a fat tube with surface sides out. Protect each surface as you roll it up with a sheet of nonwoven fabric, waxed paper, or newsprint. Shown is an assortment of prepared surfaces.

Bonny Pierce Lhotka
ROADSIDE GOLD
Inkjet print on custom-precoated recycled aluminum offset printing plate with textured
clear gel medium and pearl pigment, 26 × 24" (66 × 61 cm), 2003.

Underprinting Digital Images As a Base for Other Media

IN THIS PROCESS, you make a digital print on your chosen surface first, then add paint, pastel, colored pencil, or other media on top of the print. A digital underprint can also serve as an outline to help position painted or collaged elements and provide a strong compositional base with underlying color and detail. As such, underprinting is a natural way to start any piece that will eventually incorporate other media.

Underprinting is also a good way to begin a series that explores variations within a similar theme. The same digital image can be printed on several separate surfaces, and then each one can be developed with traditional art materials into distinctly different final pieces, all built on top of the same source underprint.

A similar underprinting process can be used to do studies on partially completed work in traditional media. For example, if you have several ideas about how to complete a painting, you can digitally photograph or scan the incomplete painting, then print the resultant digital image as several different underprints. You can then explore your various ideas in turn by painting on top of those underprints. Once you find an approach you like, you can return to the original painting, which has remained untouched, and proceed accordingly.

Bonny Pierce Lhotka
LANDING PATTERN
(DETAIL)
Acrylic paint over digital print
on clear vinyl, 24 × 24"
(61 × 61 cm), 2002

Preparing Source Imagery

In addition to creating images entirely on the computer, you can also bring existing images into the computer by digitizing them. There are three common ways to digitize an image: transfer slides of the image onto a compact disc (CD); photograph the image with a digital camera; or scan the image photo, slide, sketch, or other traditional media, using a flatbed scanner.

Slides can be scanned by a service bureau onto a Kodak Photo CD Master Disc in five image sizes, the largest megabytes being 18M. Kodak's Pro Master Disc has a sixth image size, 72M.

With digital cameras and scanning, you control the image's file size. How large you choose to make your digital image depends on how it will be used. For example, if you want to print an image at 12 × 12" and you plan to use it as an underprint, you may decide that a very soft version of the image is adequate, since other media will cover most of it. In that case, scan your image to 12 × 12" at 100 dpi, which is a lower dot-per-inch setting than you would use to get fine details. To determine the best settings for digitizing images, be guided by the chart below.

Gauging File Size

When working with digital photos, you will have to gauge the file size of an image rather than its print size and the dpi, as you would when scanning an image. Check your camera's documentation to find the total size that results from the various compression and file format options available. This total size is the file size of the image, usually given in megabytes (M). Take a photograph and open it in Photoshop to see if your chosen file format creates an image large enough for your purpose.

For soft images, it's fine to be below your target file size and simply enlarge the image to its final dimensions in Photoshop (a procedure that usually softens the image even more). If you want to print an image with detail and clarity, avoid enlarging your image in Photoshop if possible.

In Photoshop, select: File > New to open the New Image dialog box. Type in the size of your desired final image; in our example, it's 12 × 12". Type in the resolution (see chart) that corresponds to your final use; in our example, 100 dpi is chosen for a very soft image. Set the Mode to RGB. Note the image size; in our example, 4.12M.

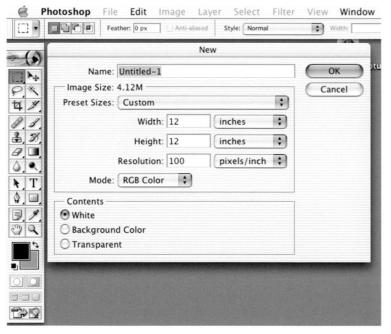

GUIDELINES FOR DIGITIZING IMAGES			
USE	RESOLUTION (in dots per inch)	FILE SIZE (in megabytes)	SIZE
Computer screen/web	72 dpi	2.25M	1024 × 768 ppi
Soft focus print/underprint	100–150 dpi	4.13M–9.29M	12 × 12"
Medium detail print	200–250 dpi	16.48M–25.75M	12 × 12"
Photographic/fine detail	300–360 dpi	37.1M–53.4M	12 × 12"

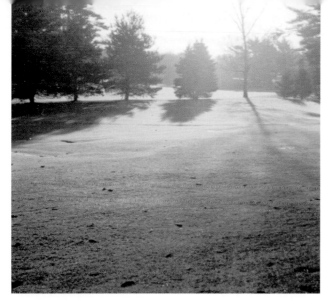

Using the same digital photo as an underprint multiple times is an excellent way to explore a single subject in great depth, detail, and to expand your color palette while assuring consistency throughout the process, as shown in the four examples below.

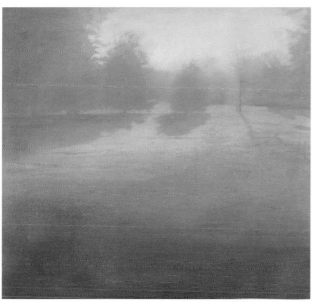

Pastel lends softness to the digital photo.

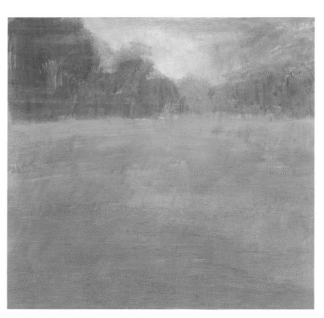

Acrylic paints brighten the picture.

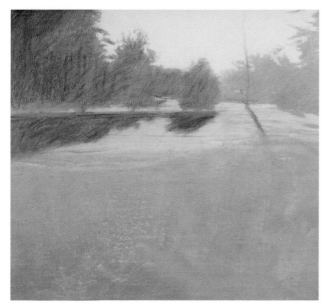

Colored pencil adds shadows and depth.

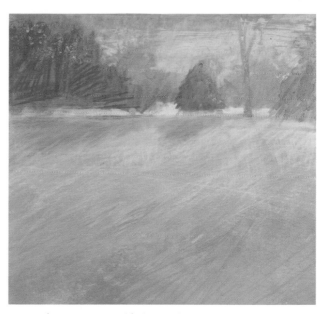

Watercolor crayons provide interesting textures.

- You can use water-based media—watercolor, acrylic, inks, dyes—under oils, but once you use solvent-based media, including water-mixable oils, oil pastels, oil sticks, and encaustic, you must continue to use solvent-based media.
- If you work with water-based media on a glossy canvas that has a gel-type precoat, your damp brush can pick up the ink and move or erase it. This potential problem can be used to advantage by touching the surface with a small amount of PVA glue and rubbing to lift and roll the edges like rough leather.

Pigment ink on gel-type precoat is picked up by a damp brush on canvas.

- If you are working with oils on a glossy canvas and prefer a less shiny finish, rub Dorland's cold wax medium into the surface after underprinting.

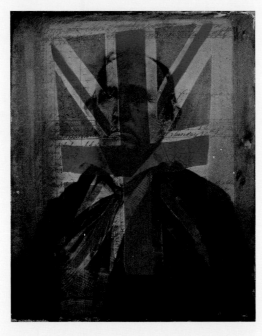

Dorothy Simpson Krause
SIGNS OF WANDERLUST
Inkjet print on canvas with abraded edges rubbed with creamy wax medium, 34 × 47" (85 × 121 cm), 1999.

- When working with oils or any solvent-based products such as Golden's MSA varnish, don't use canvas coated with white matte, as solvents will damage the surface. Choose a gel-type precoated canvas instead.

Printing Options

To create an underprint, you can use any of the substrates discussed in the first two chapters. Commercially prepared surfaces are great for images with lots of color and visual texture, but they will have no tactile variations. Uncoated surfaces work well for prints that you plan to cover heavily with other media, or for those with little color. Customized surfaces will yield the most textured and varied results.

MAKING A "GHOST" IMAGE

You can adjust software for desired levels of value, color density, and image detail to create a "ghost" to serve as an undersketch. For example, you may want to blur the image detail to soften or eliminate edges in the underprint, allowing you to make significant changes when finishing your image with traditional media. Particularly when using transparent watercolor, as opposed to acrylic and other opaque media, it's important to begin with a pale underlying image.

This original image (right) has been lightened (left), to be used as the underprint. As shown, in the Photoshop menu, select: Image > Adjustments > Hue and Saturation, then enter −50 to decrease saturation and 50 to increase lightness.

BOTH COMMERCIALLY PRECOATED canvases and those you gesso and precoat yourself are suitable for inkjet printing. For underprinting on canvas and then enhancing your art with oil paint, this process uses a digital print to create the same type of underpainting that artists establish with a thin wash of oils or quick-drying acrylics. The texture and flexibility of canvas provides a perfect surface for the buttery consistency of oil paints. Thinned, they can be painted transparently; applied thickly, they are opaque and can cover any underprint or subsequent layer. With a longer drying time than water-based media, oil paint can be worked over several hours or, when thickly applied, several days.

WARNING: Although matte canvas works well for desktop printers, pizza wheels will track through the inkjet receiver on gloss canvas.

MATERIALS

- protective gloves
- newspaper or plastic sheet to protect work surface
- canvas
- oil paints
- brushes

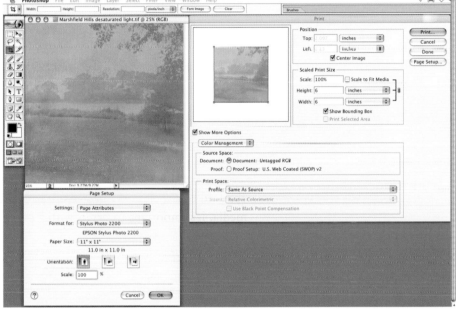

STEP 1 To ensure that you can wrap your canvas around stretchers, make it 2–3" larger in each direction than the size of the image to be printed on it. In the File > Print with Preview Dialogue Box, select: Page Setup and choose page size. In the print box, ensure that there is space around the print for wrapping. In this example, the image is 6 × 6" centered on an 11 × 11" canvas. Print the image on your canvas.

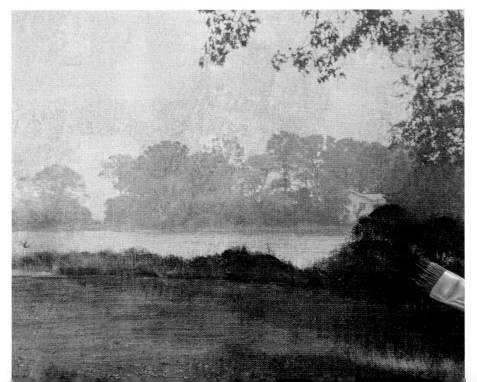

STEP 2 Using the printed image as an underpainting, work with oils on the surface.

Creative Explorations

- Almost all traditional art materials can be used on top of digital prints. Graphite, charcoal, and colored pencils work particularly well on textured papers.
- To overcome size limitations of small printers, collage underprints together before working with traditional media.
- Enlarge and print black-and-white photos. Tint or colorize them with traditional media.
- Make a print and then hand-emboss patterns on it, or use traditional print-making tools and techniques to do the embossing. Printmaking tools designed for woodblock or linoleum printing work well and can also be used to add layers of printed color.

- White and opaque paints can be used to cover areas of a print while adding texture and can be partially removed to reveal details from below. In *Landing Pattern,* on page 48, the center of the image is the digital print and the surrounding color is acrylic paint. In *Woodland,* on page 56, acrylic paint and plaster over the print create depth and texture.
- Metallic paints, gold and silver leaf, and interference and pearlescent pigments are exceptionally interesting over digital prints, especially since they are currently unavailable in most digital ink sets. While metallics add luminosity, black paint adds depth and contrast and white paint adds a surface brilliance.

Karin Schminke
SEPTEMBER
Inkjet print on handmade feather-deckle paper with gold metallic paint, 13 × 19" (33 × 48 cm), 1997.

Underprinting for Pastel

PASTEL IS AN OPAQUE MEDIUM that can be applied successfully over both dark and light and transparent colors on a wide range of commercially prepared pastel papers that come in many colors, and on precoated pastel cloth. Be aware that the vclour texture of pastel paper will show pizza-wheel tracks. You can also apply gesso acrylic primers to almost any surface to create your own pastel-friendly substrates. Pastel artists usually sketch their composition with watercolor, acrylic, or broad strokes of pastel washed into the paper with isopropyl alcohol. With inkjet printing, the underlying composition for a pastel painting can be a digital image. If you want to lighten the picture you choose, "ghost" the image before printing. Then, using the printed image as an underpainting, work with pastels to transform the print into a singular work of art.

Stabilizing Pastel

Pastel pigments sit on or near the surface, are easily smeared, and are only partially stabilized by commercial spray post-coating. Because Plexiglas attracts the pigments, pastels are traditionally framed behind glass. The post-coat formula below creates a spray that allows pastels to be hung without other protection or precoated with inkAid and overprinted with digital images.

In a small jar, combine 3T acrylic matte medium and 8 ounces of isopropyl alcohol, and shake well. Let the mixture sit for an hour, then stir and strain it into a clean container. Put the sludge remaining in the strainer back into the original jar, add a second 8 ounces of isopropul alcohol, and shake well. Let this second mixture sit for an hour, stir, then strain it into the container with the first mixture. Let the liquid sit overnight, then strain it into a labeled spray bottle. Discard the remaining sludge.

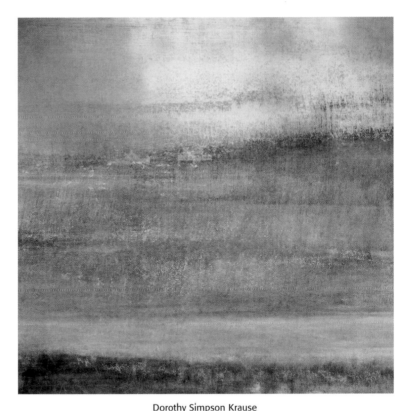

Dorothy Simpson Krause
ACROSS THE RIVER
Inkjet underprint on textured spun-bonded polyester with pastel, 24 × 24" (61 × 61 cm), 2003.

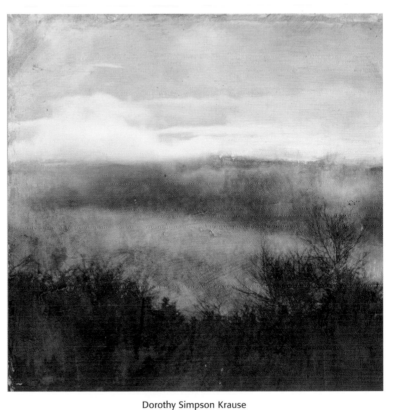

Dorothy Simpson Krause
PENINSULA
Underprint on textured spun-bonded polyester with graphite, 24 × 24" (61 × 61 cm). 2003.

What's Next

Your actual underprinting process will be determined by the art materials you wish to apply on top of your underprint. As we've seen, underprinting can serve several artistic purposes. You can use them as visual templates to be covered over by various media, or you can compose your work so that your underprints show through to the surface, adding form and variety to your mixed-media artwork.

In the next chapter, we investigate overprinting: the process of printing on top of other media that have already been applied to the substrate.

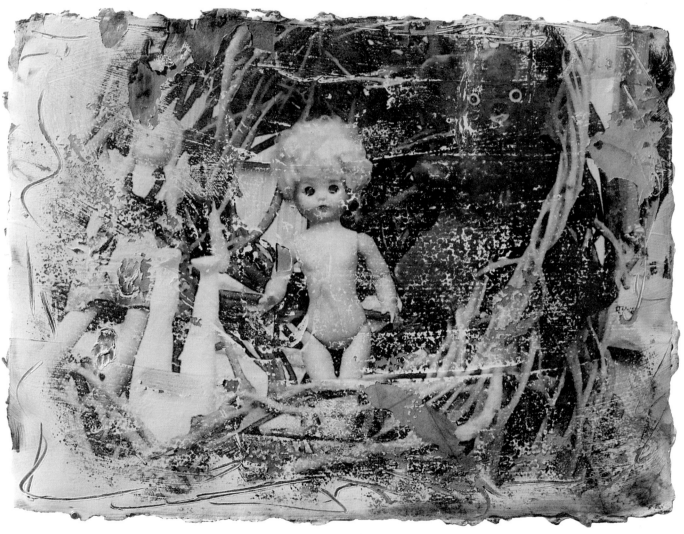

Bonny Pierce Lhotka
WOODLAND
Acrylic paint and plaster over inkjet print on feather-deckle paper,
22 × 30" (56 × 76 cm), 1999.

OPPOSITE: **Karin Schminke**
ROOTS: WATER
Inkjet print on rag paper with
black watercolor, 36 × 28"
(92 × 71 cm), 1996.

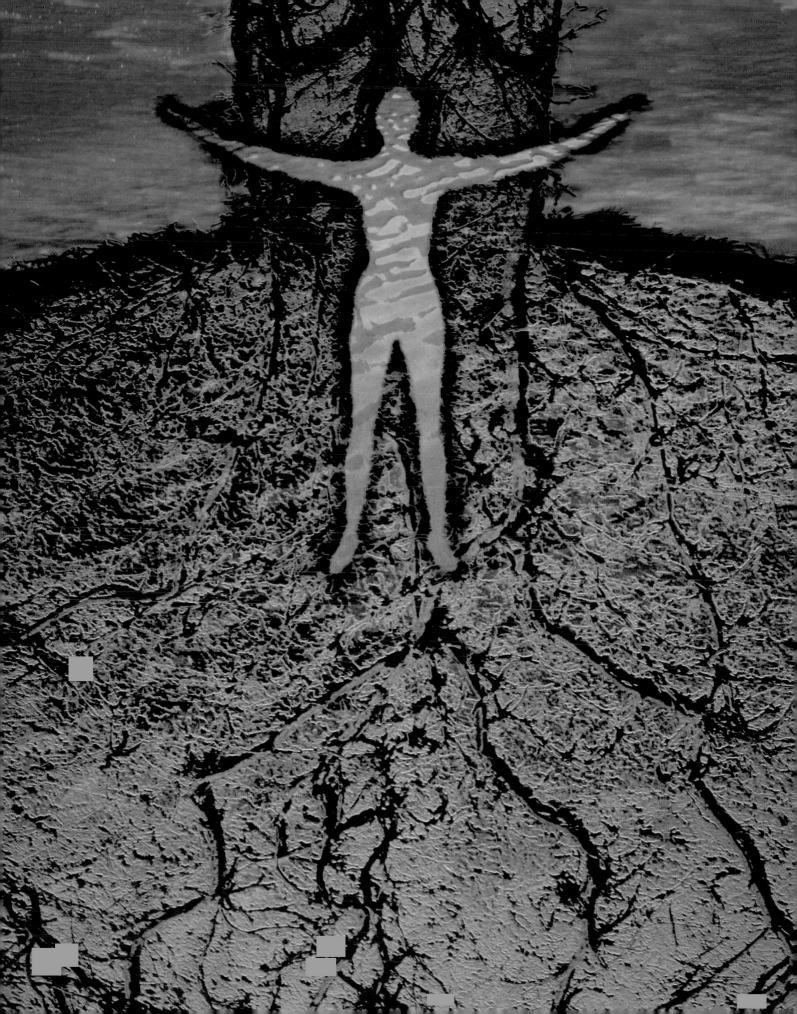

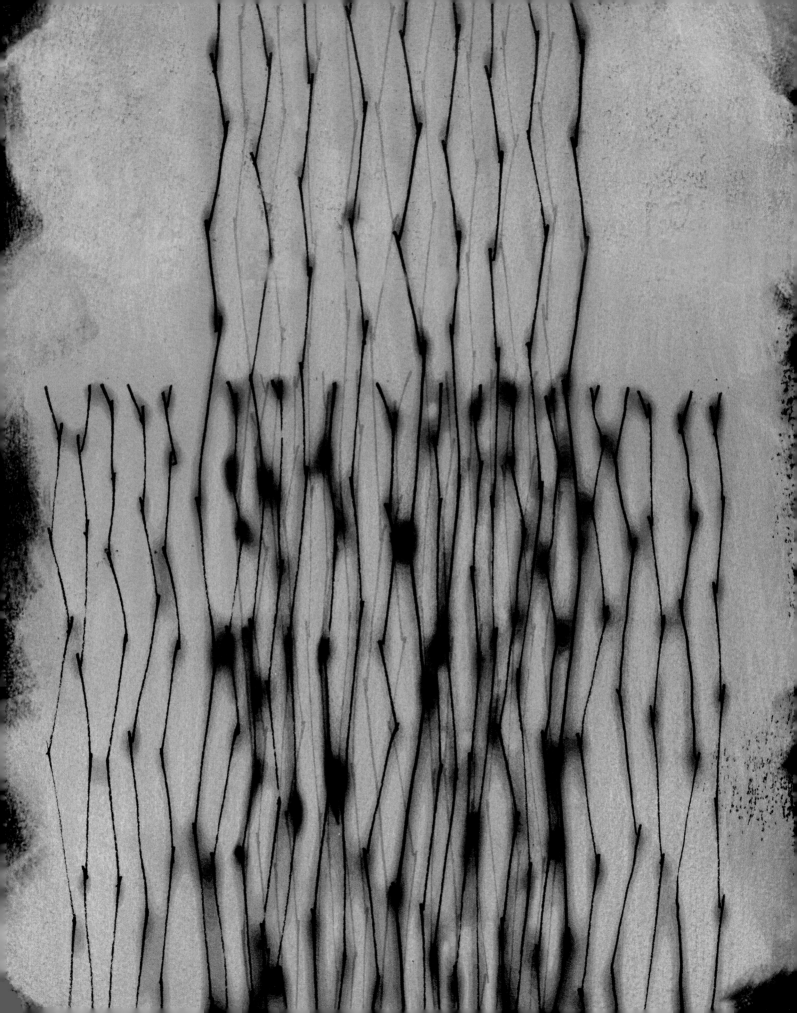

Overprinting Digital Images on Other Media

IN THIS PROCESS, you print digital images on top of artwork that you have already created with traditional art materials. Combining paint, pastel, and other media with inkjet printing results in the best of both worlds. You can utilize the wide range of textures and surfaces available to the mixed-media artist while taking advantage of the precise image control available to the digital artist—and along the way, you can even preview how your final image will look.

Inkjet prints result in a transparent overlay rather than an opaque cover on the printed surface, allowing the characteristics of the surface or underlying artwork to show through. Not only do inkjet prints over other media benefit from a richness of surface; they also gain access to a much wider color range.

Inkjet prints can also be put on surfaces not generally considered for finished work. When you create collaged surfaces, a wide assortment of art materials and everyday items can be integrated into your prints. Using these materials adds dimension and texture to a composition. Collaging also lets you build up an image layer-by-layer with translucent or transparent components, allowing the image to evolve in response to each new layer. Adding digital images to collage is a logical final step, since inkjet inks are transparent when printed. You will also be able to use photographic prints as translucent layers rather than as separate elements.

A Two-Part Process

For the processes in this chapter, you will be creating an image in two parts: first, the bottom layer with traditional art materials; then the top layer, by printing a digital image over it. Some of the processes are parallel to the customized surfaces presented in Chapter 2, so if you've already experimented with those, your familiarity with the materials will be helpful here.

Three separate bottom-layer preparations are demonstrated. In the first, we use watercolor as a base on which to print digital images; the next two processes involve collage techniques. Then directions follow for working with a camera to produce images for overprinting your art.

Karin Schminke
TRANQUILITY
Inkjet print on black rag paper with white matte precoat, 30 × 22"
(76 × 56 cm), 2003.

MATERIALS

- protective gloves
- newspaper or plastic sheet to protect work surface
- digital photograph
- watercolor paints
- watercolor brushes
- hot-pressed watercolor paper (Arches Aquarelle or similar); 90 lb for desktop printers; up to 140 lb for large-format printers
- inkAID semi-gloss or rabbitskin glue precoat
- sponge brush
- masking tape

WATERCOLOR MAKES a beautiful base for a digital image, and it's not subject to the color-gamut limitations inherent in digital printing. For example, you can use metallic watercolors in conjunction with a digital overprint to create luminous imagery not otherwise achievable by digital printing alone. Commercially precoated inkjet watercolor papers do not work well with conventional watercolor paints, as their surface is not as absorbent as traditional watercolor paper. So for this process, we'll use traditional watercolor paper. Plan your color values ahead to apply your lightest values first, as in creating a traditional watercolor. The digital photo to be printed last should add the darkest elements. Or, you may plan to fit the photo into an area of your painting left free of darker elements. (For future explorations of this process, note that instead of watercolor, acrylics, graphite, or any other medium compatible with watercolor paper may be substituted in the base layer.)

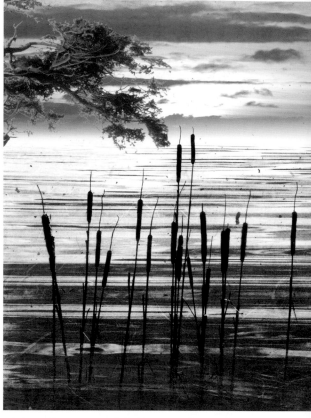

STEP 1 Choose your digital image to be used as the overprint.

STEP 2 Create a watercolor image or simply a wash on the weight of watercolor paper suited to your printer. Reference your digital image as you paint, considering its colors, values, and shapes. When your painting is dry, brush on precoat using a sponge brush; when dry enough not to run, hang the paper to dry. If it isn't flat after drying, refer to earlier instructions (page 31) for flattening.

STEP 3 If you choose to print over the deckle edges of watercolor paper, refer to earlier instructions (page 28) for taping edges.

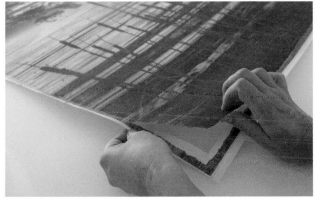

STEP 4 ABOVE LEFT: Print your digital overprint on the surface of your watercolor.

STEP 5 ABOVE RIGHT: Since the ink on the tape's edges will still be wet and may smear onto your print, remove tape carefully to reveal the deckle edge on your finished art.

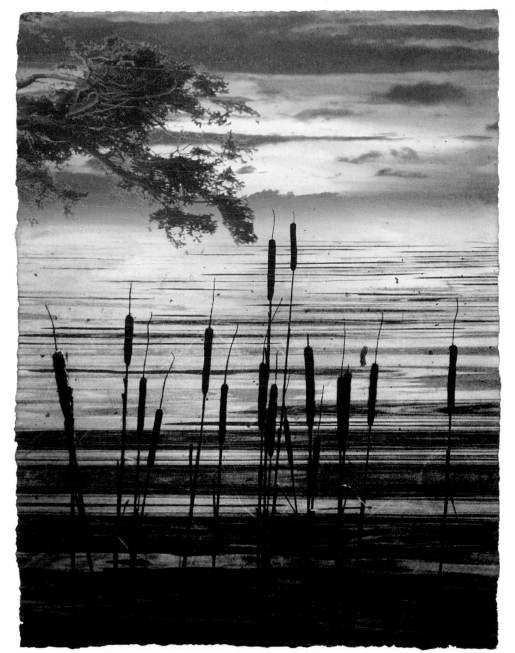

Karin Schminke
AFTERGLOW II
Inkjet print over watercolor,
30 × 22 $\frac{1}{2}$"
(76 × 58 cm), 2003.

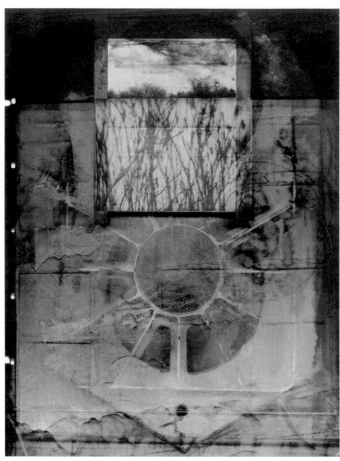

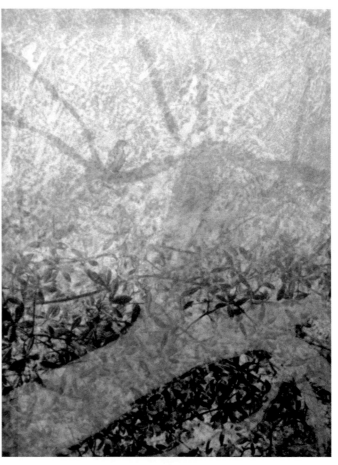

Bonny Pierce Lhotka
SUNSET
Inkjet print over layers of amber acrylic glaze, textured clear acrylic,
and gold-pigment wash, 36 × 24" (92 × 61 cm), 2003.

Karin Schminke
MEADOW'S EDGE
Inkjet print of leaf and brush patterns over mottled, multicolored
painted surface, 22 × 30" (56 × 76 cm), 1998.

Watercolor washes
and a rice-paper collage
create a colorful and
textured surface ready
to print on.

A COLLAGE MADE with a choice of art materials forms the base in this process; the collage is then overprinted with a digital image to complete the piece. In our example, we use acrylic paint and bits of paper to create a translucent acrylic collage, which is removed from its support before overprinting a digital photograph.

WARNING: This process and the variation that follows are not appropriate for desktop printers, as layers of acrylic medium create a nonporous surface, causing pizza wheels to track through your surface image.

STEP 1 To create your collage, coat a rigid polypropylene support sheet with acrylic gloss medium and let it dry.

MATERIALS

- protective gloves
- newspaper or plastic sheet to protect work surface
- rigid polypropylene support sheet
- acrylic gloss medium
- sponge brush
- acrylic paints and brush
- bits of paper or other collage items
- flexible polypropylene sheet (such as a plastic bag)
- brayer
- inkAID semi-gloss or gloss precoat or rabbitskin glue precoat
- masking tape
- Liquitex chalky gesso

STEP 2 Paint the surface with acrylic paints.

STEP 3 As a collage element, thin packaging paper is chosen for its transparent quality.

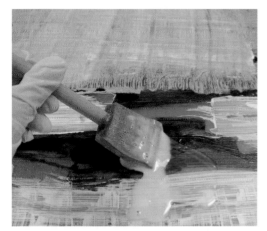

STEP 4 Use diluted acrylic medium to adhere collage pieces. The path of many printers is less than the height of a new penny, so check your printer's specifications and keep your collage within its maximum clearance.

STEP 5 Let the surface dry partially, then place a flexible polypropylene sheet over it and press the items flat with a brayer. Apply two more coats of diluted acrylic medium; brayer after each coat dries slightly. You can add even more painted elements on top of the collage.

STEP 6 After the collage has dried completely, apply a clear inkjet precoat and let it dry overnight. Trim and remove the acrylic substrate you have created from the rigid polypropylene support sheet. The acrylic medium has encapsulated the collaged materials into a flexible, but sturdy, surface that may have translucent, transparent, and/or opaque characteristics.

STEP 7 The acrylic back of the surface may be rubbery, wanting to stick in the printer, preventing it from feeding through. To prevent this, tape the substrate to a thin sheet of paper or paint the back of it with a thin coat of undiluted chalky gesso.

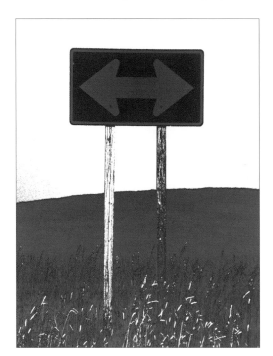

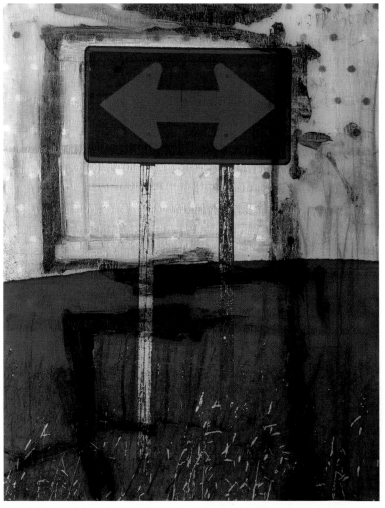

STEP 8 The digital photo (above) was considered for overprinting on the collage. The photo (right) shows what it would have looked like had it been completed. The next demonstration will show how the collage was actually used.

THIS METHOD IS A VARIATION of the previous demonstration. With large-format printers, the process offers appealing results.

We begin by scanning or photographing a collage or other art, then use the digital image as a Photoshop template. The template is a guide in creating and positioning the various elements of the digital overprint precisely on the base collage. To digitize your image, if the collage fits on your scanner bed, scan it at 100-percent size, but at a low resolution (50–100 dpi) to keep the file small, since it will be used only for positioning and won't appear in your final print. If your collage doesn't fit on your scanner, photograph it with a digital camera.

MATERIALS

■ scanner or digital camera

STEP 1 Open the digitized image of your collage in Photoshop. It should be the exact height and width of your collage. Select: Image > Image Size to increase resolution to 150 dpi without changing the height and width of the image so the overprint for the collage will be sharper.

STEP 2 Create new Photoshop layers to place your digital overprint in desired relation to your base collage. In our example, a small doll covered with the same tissue used in the collage was scanned and placed on a Photoshop layer. Additional layers of poppy photographs were added. For this procedure, unlock the collage layer by double clicking on its name. Click OK in the dialog box. Drag the collage layer to the top position in the Layer Window. Try various modes to preview how layers will work together. For Mode, select: Multiply, Darken, or leave the mode set on Normal, and use Opacity slider in the Layers window to make your top layers more transparent, thus revealing underlying layers. Experiment with modes to see which is best for the images involved.

STEP 3 As shown, we chose Multiply to preview our final composition. After you preview yours and are satisfied with it, delete or hide the reference layer containing the digitized collage, so that it won't be part of your overprint.

STEP 4 Print the image on clear film and place it over the art to check for color saturation, density, and placement. Make any necessary adjustments in Photoshop. Placing the digital image on film over the collage is a great way to check your image one last time before overprinting. Your collage may be taped to the surface of the print on film to provide exact registration for the final printing.

BELOW: **Bonny Pierce Lhotka**
POPPY GIRL
Digital inkjet overprint on tissue and acrylic collage, 24 × 36" (61 × 92 cm), 2003.

PLACE YOUR ART on a background that contrasts with the art's edges. If your art is large, place it on a wall. Set your camera on a tripod, far enough away from the art to keep from cropping it. Zoom in (if you have a zoom lens) to the tightest frame. Keep your camera lens parallel to the art, so that the art's edges are parallel and corners are squared off in the photo.

Corrections in Photoshop

To straighten unparallel edges, in Photoshop, select: Edit > Transform > Rotate and/or Edit > Transform > Distort. Whenever you use these transform tools, you risk modifying the proportions of your original image, so once you've used them, always double-check that your overall image size is still correct. The dimensions of your photo should be the same as your art. To check or correct proportions in Photoshop, select: Image > Image Size. If the proportions need correcting, deselect: Constrain Proportions, then type in the correct height and/or width of your image.

Photoshop Layers

Many wonderful effects can be achieved by layering, and layers are an important and powerful feature of Photoshop. Here are a few hints to get you started using them:

To make a new layer, click on the icon to the very left of the trash bin in Photoshop's Layers window, or select: Layer > New > Layer.

To change the layer mode, in the upper-left corner of Layers window, click Mode, and from its drop-down menu select your desired mode. Alternately, from the main Photoshop menu, you can select: Layer > Layer Style > Blending Options > Blend Mode.

To hide a layer, click on the eye icon next to it in the Layers window. To make the layer visible again, click on the blank square where the eye icon was. The eye icon (and your layer) will reappear.

To delete a layer, drag it to the trash bin in the Layers window, or select: Layer > Delete > Layer.

Dorothy Simpson Krause
SWEET CANE
Inkjet overprint on watercolor, diptych, 12 × 24"
(31 × 61 cm), 2001.

- If you are unhappy with your print, you can wash the image off the collage and reprint over a clear precoat. Place the collage on a rigid polypropylene sheet and gently rub it with cold water until the image is removed. Press the collage flat on the polypropylene support. Let the collage dry and reapply an inkjet precoat. This technique works especially well on images that have a layer of acrylic medium under the precoat, which acts as a waterproof barrier. If the overprint does not wash off completely, a ghost image from an earlier print may be a welcome addition.

- If there is a head-height adjustment on your printer, set it to the maximum height to help the heads clear as the surface is printed. Some printer software will override a maximum-height setting, so make sure to also select the proper head height in the printer driver or RIP if such an option is available.

- To increase image density, some software, RIPS, and/or printers allow a double strike of the image, which puts more ink on the paper, greatly boosting color density. With printers that do not allow a double strike, you still may be able to realign your print and reprint with a "reload" command before removing it from your printer. This method aligns the print fairly close to the original. Unfortunately, both of these features are relatively rare in printers.

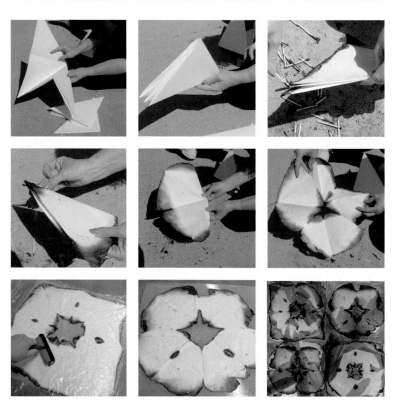

Create unique collage elements by burning the edges of tissue or rice paper and applying them to your collage with gloss medium.

Creative Explorations

- Other media that you can use as an underlayer or integrate into a base collage include black-and-white and color photos, newsprint, letters, fabrics, watercolor, charcoal, and any other traditional art materials.

- Tint white precoat with watercolor to give your print a color variation.

- Paint white precoat on black paper as an underpainting. Vary the density and texture of the precoat—thin, thick, and dry-brushed—to give different levels of intensity to your overprinted image.

- Add color to woodblock or linoleum prints by precoating them and then overprinting with color fields. As you plan your image, keep in mind that digital inks are very transparent.

- Create unique collage elements by burning the edges of tissue or rice paper and applying them to your collage with gloss medium.

- If you have access to a flexible media or flatbed printer, you can print on materials with thickness up to several inches, limited only by the printer's head clearance.

What's Next

Printing digital images over watercolor or mixed-media collages can take traditional artwork to new levels. As we've seen in the above processes, it creates a new hybrid way of composing your work. The more you experiment with digital overprinting, the more comfortable you will become with its particular nuances.

Now you're ready to take your basic understanding of preparing surfaces, underprinting, and overprinting, and apply it to more advanced processes in the six chapters that lie ahead.

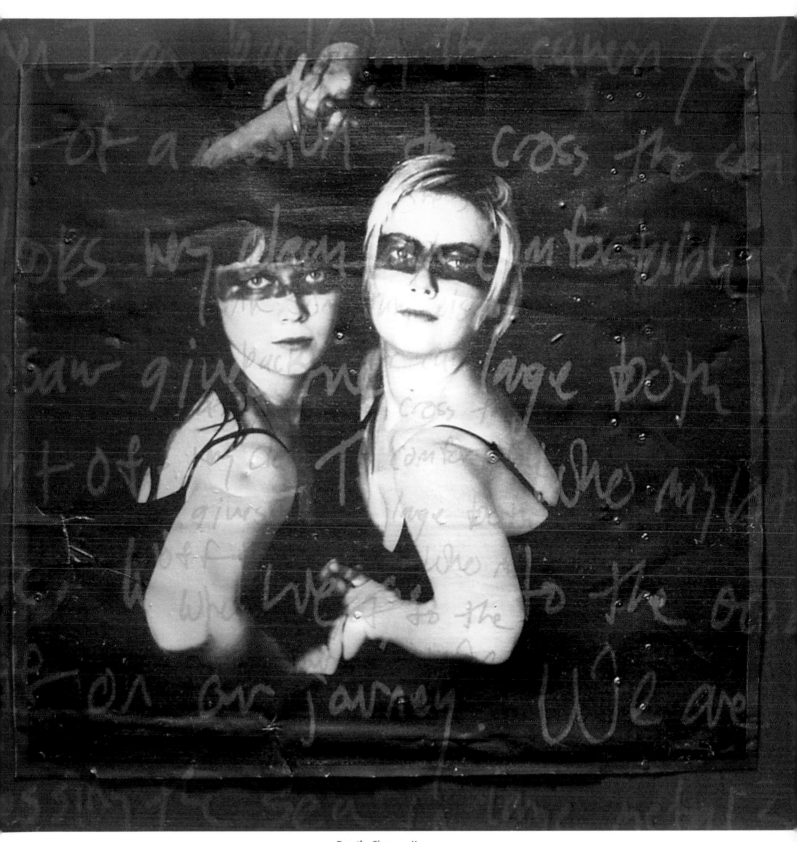

Dorothy Simpson Krause
DANCE 6
Ultraviolet-cured inkjet print directly on painted metal nailed to plywood, 24 × 24" (61 × 61 cm), 2002.

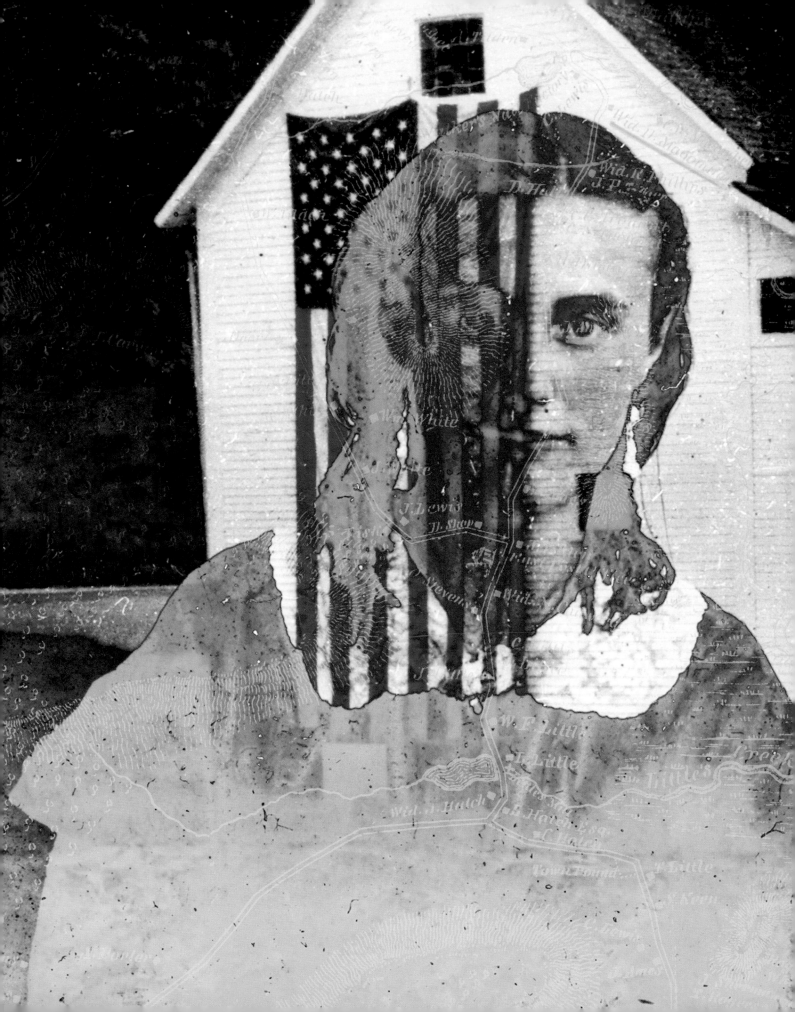

Part Two
Advanced Processes

THE REMAINING CHAPTERS of our book explore advanced processes that result in greater complexity and richer forms than the basic methods discussed in Part One. We begin with transfer processes—wet transfers, dry transfers, gelatin transfers. As their name suggests, transfers are images that are moved from one surface to another. The final three chapters focus on the layering of prints; creating three-dimensional images; and printing on fabric.

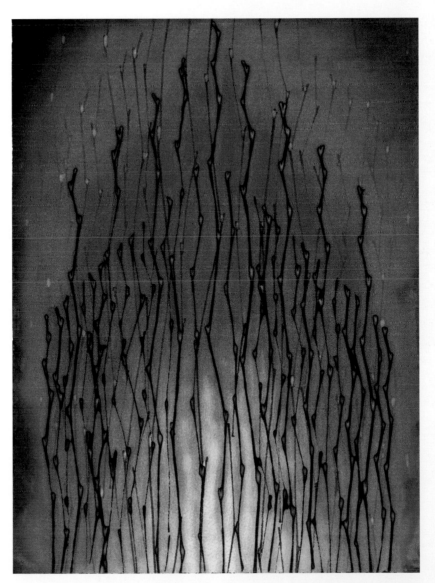

LEFT: **Karin Schminke**
DESIRE
Inkjet print on black rag paper, precoated with white matte, 30 × 22" (76 × 56 cm), 2003.

OPPOSITE: **Dorothy Simpson Krause**
INDEPENDENCE DAY (DETAIL)
Inkjet print on canvas, 47 × 34" (120 × 85 cm), 1999.

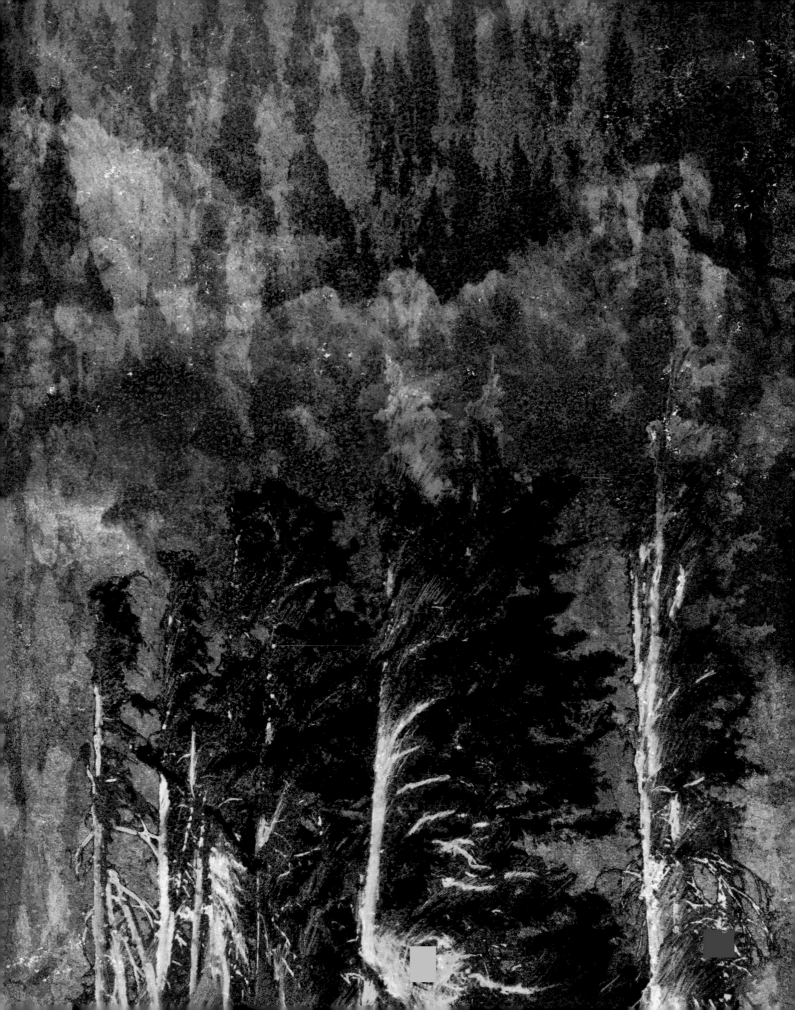

Wet Transfers to Absorbent Surfaces

TRANSFER PROCESSES are appealing because they allow you to apply photographic or other digital imagery to a variety of materials easily, particularly materials that might not fit through your printer. As such, they often result in irregularities that can add warmth and interesting characteristics to your art.

In the past, artists have transferred copier and laser prints using solvents, often disregarding potential safety issues. Two examples of less hazardous transfer processes are monoprints and Polaroid transfers. In a traditional monoprint, you paint on a sheet of plastic, place it facedown on dampened paper, and transfer the image from plate to paper by passing the two through a press. With Polaroid transfers, you expose the film and immediately place it facedown on damp paper, so the image develops on the paper rather than on film. By comparison, wet transfer offers more production options, and allows you to work at larger scales with relative ease.

To create a full-bleed image, print your transfer larger than the paper it will go on. You can also transfer your image to the center of a sheet that is too big to fit through your printer. Transferring multiple smaller images to a large sheet of paper is a good way to develop a collage. And because wet transfers have a soft quality, they are ideal for low-resolution images from a digital camera, and for images printed on a low-resolution printer.

Two Components

Two major components make up the wet-transfer process: film and paper. First, you print your digital image on a precoated, nonporous, polyester film that will easily release the image. Next, you press this carrier surface (with the digital image printed on it) against dampened paper to activate the image transfer.

The wet-transfer process was developed years ago with standard inkjet films. Unfortunately for artists, manufacturers "improved" their inkjet films to make the images printed on them more permanent. Consequently, most commercial inkjet films no longer work as transfer carriers, since they won't release the images printed on them. Océ FCPLS4 is one film that can be used for transfers; however, the resulting image is less dense than optimal, especially with wet transfers to paper. Coating your own transfer film produces images with richer colors, and is preferred for the processes in this book.

Karin Schminke
MALACHITE
Wet transfer to sized paper
with black watercolor,
19 × 15" (58 × 38 cm),
2003.

Transfer Film

Most inkjet films are precoated poly-ester. To use for wet transfers, they must be coated with a transfer mixture, as described below. Two brands are recommended for coating; each has its own advantages.

Dura-Lar (5 mil) is the preferred material when you're transferring to sized papers. It's sold in single sheets, pads, or rolls, and requires two coats of transfer mixture. As it is easiest to find in art-supply outlets, it is a good material on which to build your experiments.

Kimoto Silkjet SC4 is a commercially precoated film intended for making transparent inkjet prints. To use it for transfers, you need apply only one additional coat of transfer mixture, making it preferable for large-scale production. It is also recommended for gelatin transfers, covered in a later chapter.

Making Transfer Mixture

Although full-strength inkAID works reasonably well for wet transfers, the following variation spreads more smoothly and releases from the transfer film more easily, resulting in more successful transfers. Once mixed and stored properly, it will last for months.

WARNING: Because this recipe is made with clear precoat, when applied to a transfer film, it is not suitable for printers with pizza wheels, which will drag through the damp ink, leaving vertical smears. Use Océ Graphics film FCPLS4 on printers with pizza wheels; it will not track.

MATERIALS
- 1 teaspoon Golden Acrylic Flow Release
- 3 tablespoons distilled water
- 2 cups inkAID gloss precoat

1 Combine the water and Flow Release; add the inkAID and mix thoroughly. Label and store in a clean container with a lid.
2 Coat your film with transfer mixture, using a sponge brush to avoid streaks. Dura-Lar requires two coats; Silkjet, one coat.
3 Allow your coated transfer film to dry overnight before using.

Waterleaf Paper

Fine-art papers without sizing are called "waterleaf" papers. They soak up moisture like a paper towel and have a very soft surface, making them inappropriate for media such as watercolor or ink. However, these same absorbent qualities make waterleaf papers ideal for monoprints and wet digital transfers. Arches 88 is one of the most beautiful, well-known, and readily available waterleaf papers—our preferred surface for the demonstration that follows.

The transferred image (right) adds subtleties to this photograph of a magnolia, as compared with the crisp image printed on semi-gloss paper (left).

IN THIS PROCESS, a horizontally flipped image is printed on a precoated polyester transfer film and pressed against dampened waterleaf paper. Be prepared for irregularities in transferred images; embrace such "happy accidents" as a natural byproduct of the process, and don't throw away your failures! In a later chapter, we will build images one layer at a time, and imperfect prints make a wonderful starting point. Since wet transfers require practice, it's best to start with small images (10 × 12" or smaller) to get a feel for the process.

MATERIALS

- protective gloves
- prepared transfer film, 1" larger than the image to be transferred
- digital image
- polypropylene sheet to protect work surface
- Arches 88 waterleaf paper
- water spray bottle
- cotton terrycloth towel
- rolling pin

STEP 1 Trim your prepared transfer film to give it squared-off corners to feed straight through your printer. Flip your digital image horizontally in your software and print it on your prepared film. If your printer cannot read a transparent sheet, put white paper under your clear transfer film. Wait until the ink dries overnight and won't smear. When dry to the touch, the surface may feel a bit rubbery, but the image will still transfer. You can even let the surface dry over many weeks, and the image will still transfer.

STEP 2 To make cleanup easier, place your waterleaf paper on a large polypropylene sheet. Spray generously with cold water until evenly wet. The surface should stay shiny with moisture for about ten seconds after spraying. Don't use a brush; it will cause the surface to pill. When the paper begins to ripple, as shown, it is only about half wet enough. Carefully lift the paper's edges and wipe underneath so moisture will not transfer the image onto your work surface. This step is especially important if you plan to transfer beyond the edges of the paper. To remove any air bubbles, pick up an edge of the paper by its two corners and lift toward the center. Then slowly "roll" the paper back down, perfectly flat, onto your work surface. Repeat for the other half of the sheet of paper. Let the paper set for about ten minutes to even out the moisture.

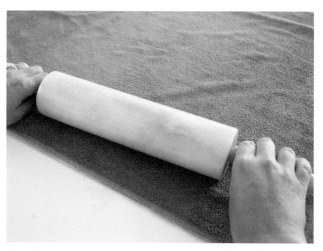

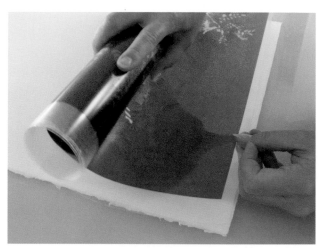

STEP 3 Cover your wet paper with a terrycloth towel and gently smooth out any wrinkles. Using a rolling pin, go over the cloth to absorb excess water. Apply very light pressure. If you use a marble rolling pin, apply no additional pressure. Remove the towel.

STEP 4 Roll up the transfer film with the print side out. Align it at the edge of the damp paper, and unroll it slowly to ensure that air pockets do not form under the film. (Do not drop the film flat on the paper because that could cause an air pocket and damage the transfer.) Smooth the transfer film gently and briefly with your hands. Cover it with the towel and use a rolling pin with light pressure to ensure that the transfer film and the paper make contact in all areas.

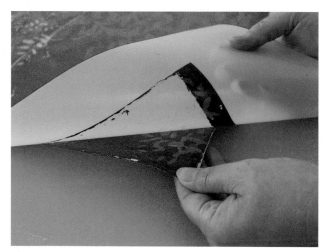

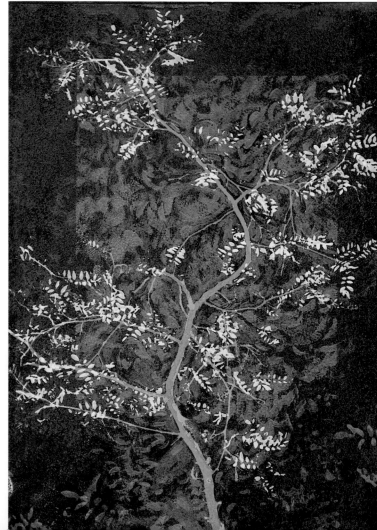

STEP 5 Wait about twenty minutes, remove towel, then gently peel back and begin to remove the film slowly. If your paper has deckle edges, rub the film area over them with your fingertip to encourage edges to transfer as you remove the film. If other areas are not transferring, wait another few minutes. Also try gently pressing down on slow-transferring areas, but be careful; too much pressure will show on the print. After removing the film, let it dry partially before handling the print.

Karin Schminke
GOLDEN GARDEN
Wet transfer to waterleaf
paper, 20½ × 15"
(53 × 28 cm), 2003.

Other Paper Choices

While many handmade papers have no sizing, most art papers do have some, so if you experiment with papers whose sizing content is unclear, your transfer may be less clean, with more of the image staying on the transfer film.

Rives BFK comes in both sized and water-leaf versions. Some Thai and Japanese papers also work well. Twinrocker Feather is a water-leaf paper with an especially beautiful deckle. Look for papers that will absorb water, but also have strength-adding fibers or are a bit thicker, so they won't fall apart when wet.

Transfers to sized papers are more difficult, but with access to a printing press (etching, hydraulic, or vacuum press), you can transfer handmade papers, woven or collaged papers, and wood or veneer. You will need to soak and blot sized papers thoroughly for successful transfers. Place a 1-mil plastic sheet between the blanket and wet paper to act as a moisture barrier. You can even use very heavy watercolor paper with feather deckles for transfers with a printing press. A smooth, hot-pressed paper gives the most consistent transfer, whereas the texture will remain visible in a rough, cold-pressed paper. A press also allows you to emboss paper with materials that integrate or contrast with the image.

FAR LEFT: In lieu of a press, a CODA laminator may be used to transfer to sized paper.

LEFT: A fifty-pound steel brayer, custom-made by a tool-and-die shop, is another substitute for a printing press. The smoother the paper, the more evenly the image will transfer.

Orange Thai kozo paper (right) makes a dramatic transfer, although the mango leaves embedded in it prevent a perfect transfer.

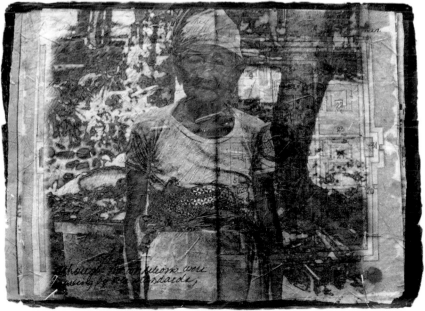

Dorothy Simpson Krause
PLAN OF THE PALACE
Transfer to Japanese rice paper, 22 × 30" (56 × 76 cm), 1998.

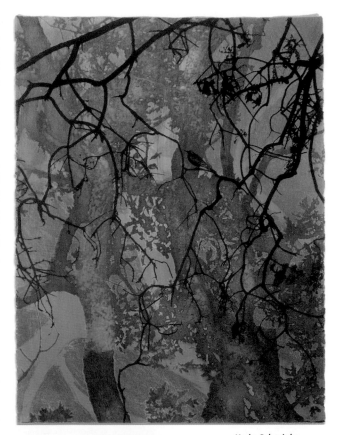

Dorothy Simpson Krause
PLEA
Digital transfer on sized
paper, transferred with an
etching press, 30 × 22$\frac{1}{2}$"
(76 × 57 cm), 1998.

Karin Schminke
FRAGMENTS: RIDGE
Digital transfer on sized
paper, transferred with an
etching press, 30 × 22$\frac{1}{2}$"
(76 × 57 cm), 1998.

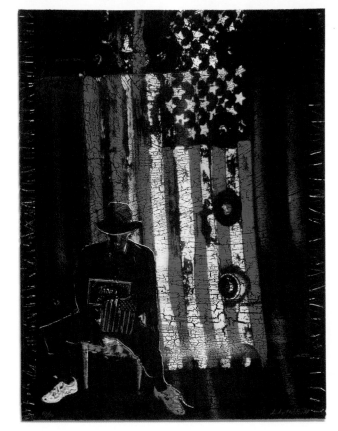

To celebrate the one-hundred-
twenty-fifth anniversary of the
founding of Massachusetts
College of Art, during an artist-
in-residence program, we
created these digital-transfer
prints, which were transferred
using the school's etching
press, and then presented
as our gift to the college.

Bonny Pierce Lhotka
AMERICAN DREAM
Digital transfer on sized
paper, transferred with an
etching press, 30 × 22$\frac{1}{2}$"
(76 × 57 cm), 1998.

Trouble-shooting Wet Transfers

GETTING A FLAWLESS transfer print takes practice and luck. And it bears repeating that irregularities are part of the process, bringing a welcome individuality to each print. But to overcome potential problems as you work on improving your technique, here are some troubleshooting tips. In fact, you can even reverse-engineer these common snags to *add* irregularities to your transfers.

TIPS

- If the image transfers completely off the carrier, but the transferred image is evenly light, try increasing the density of the digital image 10–15 percent, using your software's "saturation" or "curves" setting. A third coat of transfer mix may also increase color density
- If the paper seems to be glued to the print, you may have rubbed too hard on the film or let the paper dry before removing the transfer film. Be aware that if you set the paper on an absorbent surface, it can cause the paper to dry by wicking moisture out of the paper.
- Remember to flip your image before printing.
- When using Epson Ultrachrome inks, select matte black ink.

STREAKS If untransferred areas have brushstroke shapes, as shown here, it means you applied the carrier precoat unevenly, causing it to be too thin in those areas. If that happens, using a sponge brush, apply your precoat evenly.

TOO WET The flow pattern of this image being washed by excess water is visible. If areas of the print are washed out, or if the surface seems "bubbled," the paper was probably too wet. In that case, your carrier will be washed nearly clean, which would not happen with less-wet paper.

TOO DRY If a lot of the image was left on the carrier, the paper was too dry, as is evident in this transfer. Adding or leaving more moisture in the paper on your next transfer will help the problem.

CENTERING Aligning a print in the center of wet paper can be difficult, since contact between carrier and paper will smear the image. To position your paper correctly, prior to soaking it, make light pencil marks to serve as a guide.

Image wet-transferred to sand-blasted glass with a print of the same image left placed behind the glass to create a sense of depth.

Creative Explorations

■ On your printed film, before it is transferred, paint with traditional water-based art materials. This is an interesting way to add white and metallic pigments to your image.

■ Print various images on precoated transfer films. Selectively transfer one image at a time to wet paper to create a collage. This works especially well if you have a small printer and want to work larger.

■ Experiment with other nonpaper surfaces such as marble or etched glass to receive your transfer. Select surfaces with a little tooth so that they will hold moisture. Also, choose surfaces that won't warp when soaked in water.

What's Next

No matter which printing surface you choose, wet-transfer images have a unique quality that can't be achieved by any other process. But our focus in the next chapter is equally fascinating in its own way—another transfer process that also yields distinctive results: dry emulsion transfers.

Image wet-transferred to marble.

Image wet-transferred to a sanded rigid-plastic surface.

Bonny Pierce Lhotka
IRONMAN BOB
Wet transfer to woven paper,
22 × 30" (56 × 76 cm),
1998.

Dorothy Simpson Krause
HARLEQUIN
Wet transfer to old wood
with white paint added,
(diptych) 20 × 20"
(61 × 61 cm), 2002.

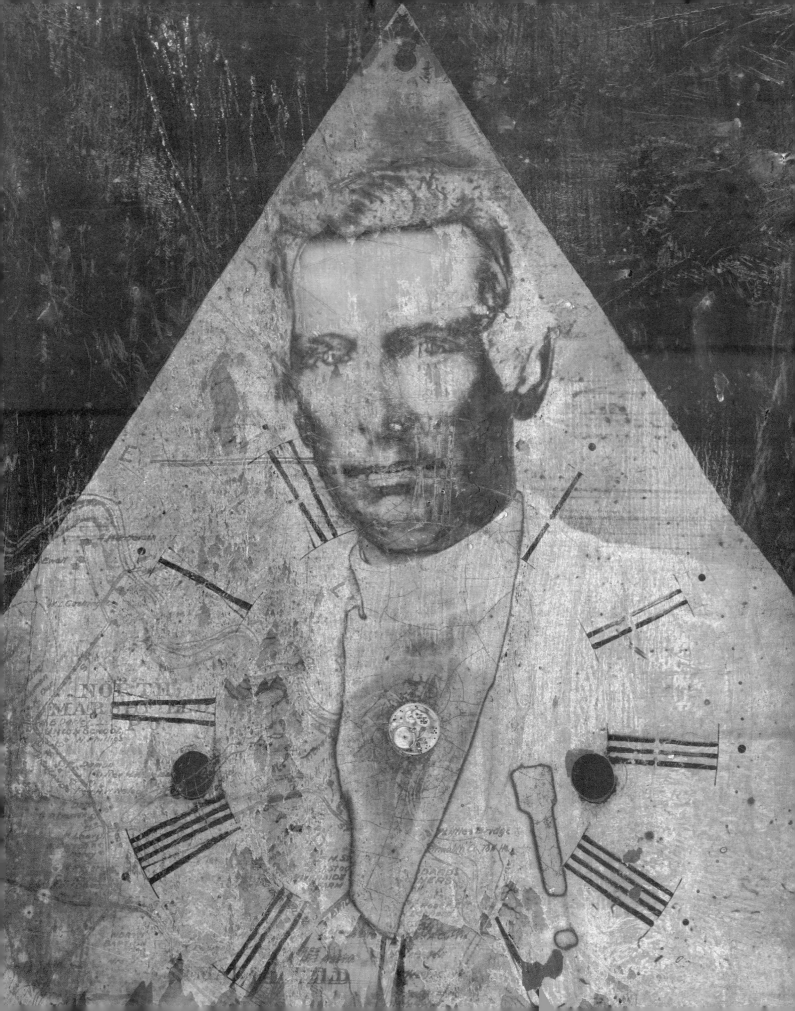

Dry Emulsion Transfers to Nonabsorbent and Dimensional Surfaces

SEVERAL YEARS AGO, while we were pulling the protective cover from a sheet of adhesive-backed silver paper, the digital image came off instead, bringing with it the gelatin precoat and part of the silver paint from the paper. This removed "skin" had a translucent quality that showed promise for some interesting imagemaking.

In our attempt to duplicate this accidentally created skin, we developed a dry emulsion process that creates a sheer "skin." It is similar to a Polaroid emulsion, in which you remove the gelatin coating that contains the developed image by floating the film in warm water. Then, you adhere this coating to another surface. But the prints are small, very fragile, and tend to wrinkle and stick to themselves.

Our dry emulsion "skin" is also similar to "waterslide" decals by two companies: Bel and Lazertran. To use those products, we print an image on the decal paper, place it in water until the image floats off of its backing, then adhere the image to art paper or other surface. However, the decal process also has its drawbacks, because the image cannot exceed 11 × 17" and only works with dye-based inks or laser prints.

Fortunately, our process, while similar to both film and decal techniques, overcomes their shortcomings in helpful ways: Our material doesn't need to be removed in water; it can be any size; it's more durable; and you may handle the skin when it's dry, which allows cutting and molding it to shaped surfaces. Although we've used the words *skin, film,* and *decal,* the word *emulsion*—a viscous medium that forms a coating—is more accurate, hence our coinage: "dry emulsion transfer." Unlike other art materials, dry transfer creates a distinct encapsulated layer that combines with other media while retaining its original character.

Basic Processes

This chapter presents two ways to make dry emulsion transfers. The first process creates a clear and flexible emulsion. Because it has an underlayer of acrylic medium, it may be glued with a clear-drying, water-soluble adhesive. The second process creates a white emulsion that also has an underlayer of acrylic medium, as well as a water-resistant surface. Both emulsions are flexible and sturdy.

Dorothy Simpson Krause
PREACHERMAN
Emulsion transfer with silver backing to print on paper, 47 × 34"
(120 × 85 cm), 1999.

ABOVE: You may handle the emulsion skin when it is dry, which allows you to cut and gently mold it into the shape of a dimensional surface.

Making a Reusable Polypropylene Carrier Sheet

For both of the emulsion-transfer processes ahead, you will need a polypropylene carrier sheet. Polypropylene is a rigid plastic and nothing sticks to it. If your printer can accommodate the thickness of a mat board (1.5mm), purchase a sheet of $^1/_{16}$" polypropylene. If your printer's maximum allowable media thickness is less than 1.5mm, use plastic bags or 4-mil polypropylene sheeting sold in hardware stores. To make the sheeting semi-rigid, cut a heavyweight paper with a smooth surface to the size of the polypropylene. Spray 3M 77 Adhesive on the paper and mount it on the polypropylene, removing all wrinkles.

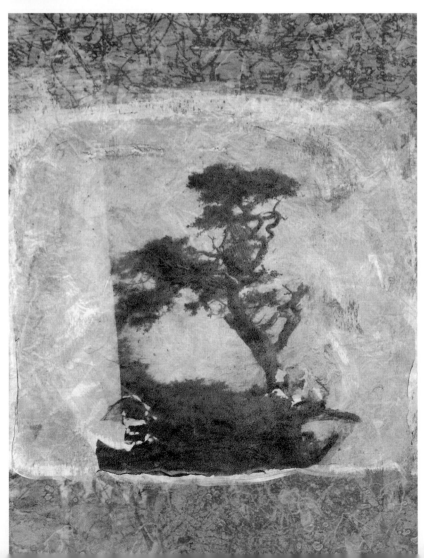

Karin Schminke
REVELATIONS
Clear emulsion transfer overlaid on painted and printed surface, 30 × 22"
(76 × 56 cm), 1999.

THIS PROCESS CREATES a clear emulsion that will accept pigment ink. The emulsion may be adhered to rough, textured, or even three-dimensional surfaces. Because the emulsion is clear, the surface to which it adheres will show through it. Prepare your polypropylene carrier sheet by cutting it larger than the image you wish to print; clean the sheet with vinegar, rinse, and wipe dry. To create your emulsion base, this sheet receives four coats before printing, with long drying times between coats. Brush on the first coat of undiluted acrylic gloss medium and let dry; apply a second coat and let dry overnight. Brush on a coat of inkAID gloss precoat and let dry overnight; apply a second coat crosswise to the preceding one and let dry overnight. These four coats create a base for your clear emulsion transfer. But before you proceed, note the following:

WARNING: Since ink wets the surface of a clear emulsion transfer, do not use printers with pizza wheels, which will smear the print and leave a hard-to-remove gummy precoat residue on printer rollers.

MATERIALS

- protective gloves
- newspaper or plastic sheet to protect work surface
- polypropylene carrier sheet, 1.5mm thickness or less
- vinegar
- sponge brush
- acrylic gloss medium
- inkAID gloss precoat
- image to be printed
- Krylon Crystal Clear acrylic coating
- 2" package tape
- X-Acto knife

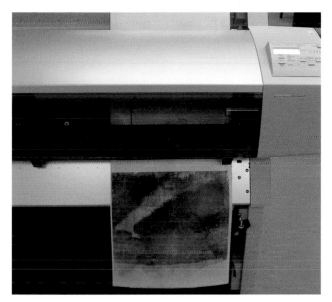

STEP 1 With the emulsion base on the carrier sheet, feed through the printer; your image prints on the emulsion base. (In our photo, the carrier sheet is long enough for two images.) Since the emulsion transfer will be printed faceup, you need not flip the image. Let the ink dry overnight, then spray with Krylon Crystal Clear to provide resistance to water damage.

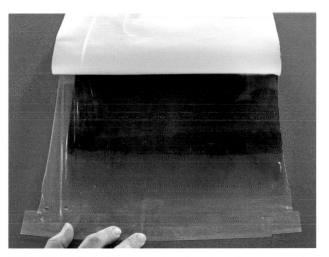

STEP 2 To assist in lifting the printed emulsion from the carrier sheet, place tape across the top edge of the printed emulsion. Fold the tape onto itself to create a lifting "handle."

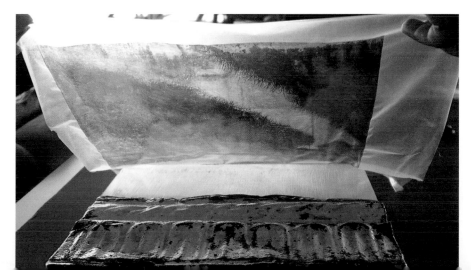

STEP 3 With acrylic gloss medium, coat the surface to which you will adhere the emulsion transfer. This coat goes down milky but dries clear and will act as glue. Let the coat dry until tacky, then carefully position the emulsion on the surface. (In our example, the surface is a combination of metal and mirror.)

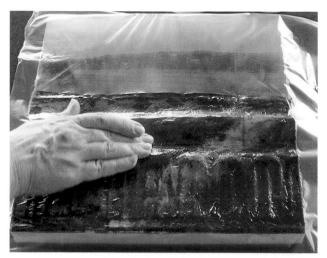

STEP 4 With fingers, shape the emulsion to the surface. Puncture any air bubbles with an X-Acto knife. Let dry.

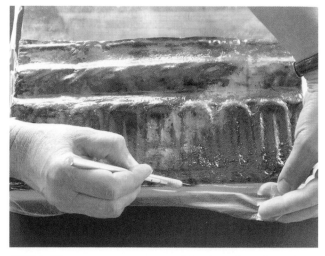

STEP 5 Trim away any excess emulsion from the edges of your printed emulsion surface.

Dorothy Simpson Krause
STREAM
Clear emulsion transfer to surface comprising a three-dimensional tin ceiling tile at the bottom and a mirror at the top, 12 × 12" (31 × 31 cm), 2003.

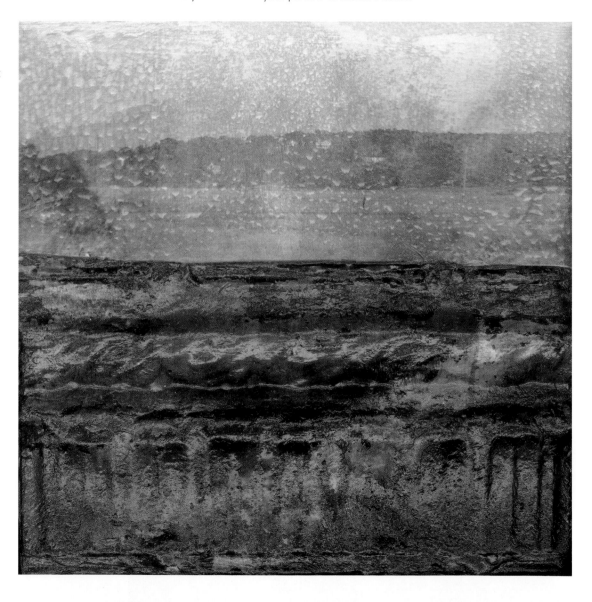

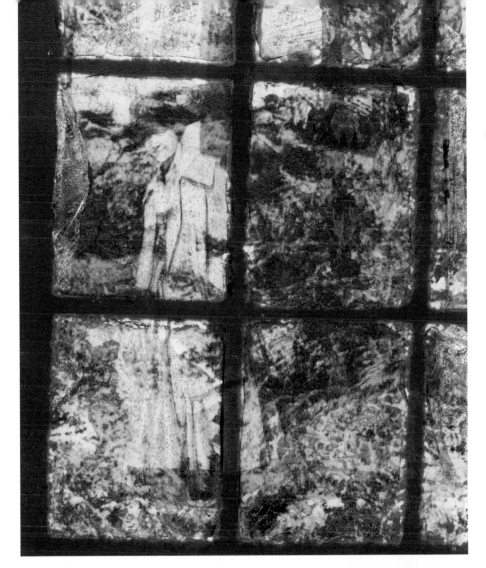

Dorothy Simpson Krause
SHADOWS ON THE BACK WALL
Emulsion transfer with silver backing cut
into pieces and adhered to print on paper,
47 × 34" (120 × 85 cm), 1999.

Bonny Pierce Lhotka
FLIGHT LANDING
Clear emulsion transfer over colored
pencil and acrylic on board, 18 × 18"
(46 × 46 cm), 2003.

MATERIALS

- protective gloves
- newspaper or plastic sheet to protect work surface
- polypropylene carrier sheet, 1.5mm thickness or less
- vinegar
- sponge brush
- acrylic gloss medium
- white acrylic paint
- inkAID white matte precoat
- image to be printed
- 2" package tape
- X-Acto knife

THIS PROCESS CREATES a flexible, water-proof, white emulsion "skin" that will accept pigmented ink. The emulsion may be adhered to rough, textured, and sculptural surfaces. Because the emulsion is solid white, the surface to which it adheres will not show through. Prepare your polypropylene carrier sheet by cutting it larger than the image you wish to print; clean it with vinegar, rinse, and wipe dry.

This sheet receives three coats before printing, with long drying times between coats.

Since ink dries immediately on the white emulsion transfer, this process is safe for printers with pizza wheels. Set the media lever to "thick paper" and select the highest head height in the printer driver. On some Epson desktop printers, you can feed your carrier sheet through the flat feed slot in the back.

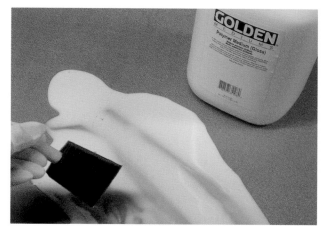

STEP 1 On the polypropylene carrier sheet, paint a coat of undiluted acrylic gloss medium and let dry.

STEP 2 Apply one smooth coat of white acrylic paint over the gloss medium and let dry overnight; then apply an even coat of white matte precoat and let dry overnight. These three coats provide a base for white emulsion transfer.

STEP 3 Since the emulsion transfer will be applied to your surface faceup, you need not flip the image. Print your image on the emulsion base. Peel the printed emulsion from the carrier sheet. The printed white emulsion is water-resistant. With acrylic gloss medium, coat the surface to which you will adhere the printed emulsion transfer. This coat will act as glue. Let the coat dry until tacky.

STEP 4 Position the emulsion transfer faceup on the glue-coated surface and burnish gently with your fingers. In our example, shoe polish is rubbed into the white emulsion as a final step.

Bonny Pierce Lhotka
SPOTTED FISH
White emulsion transfer adhered to board, burnished with oils, wax, and shoe polish, 24 × 36" (61 × 92 cm), 2003.

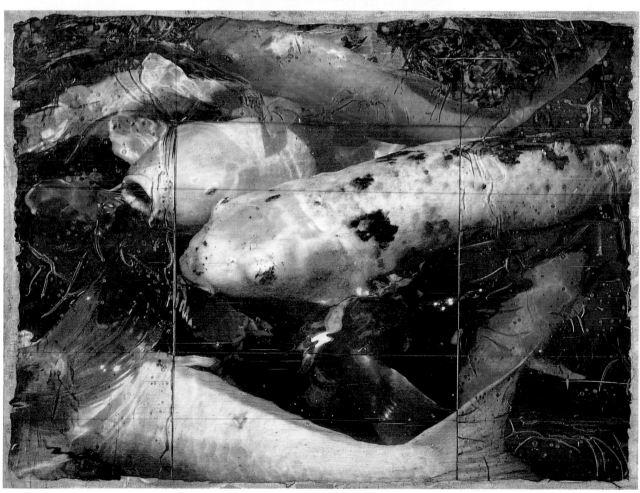

Ultrasheer Emulsion Transfer

To make a very delicate, water-soluble, cellophanelike version of an emulsion transfer, omit the layer of acrylic medium, use three coats of inkAID clear gloss precoat, and build this ultrasheer emulsion on a thin polycarbonate carrier sheet. Print on the emulsion base, let dry overnight, and carefully remove it from the carrier sheet. Ultrasheer emulsion transfers tend to stretch and stick to themselves, especially in a humid environment. Capitalize on this property by folding and wrinkling it beforehand or as you adhere it to your chosen surface. This process will not work with pizza wheels.

Remove the ultrasheer emulsion transfer and adhere it to your chosen surface, using a UHU glue stick or non-water-soluble adhesive. Spray with Krylon Crystal Clear to protect and seal the surface after it is in place.

A fragile emulsion transfer can stick to itself, so be careful in handling it.

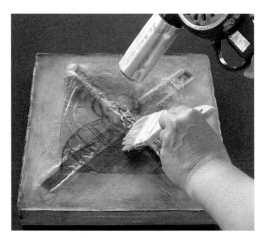

Use a hair dryer or hot-air gun if you wish to soften the emulsion as you press it into a three-dimensional surface, such as this one, which includes embedded metal rods as part of the artwork.

RIGHT: **Dorothy Simpson Krause**
PATRIARCH
Clear emulsion transfer to plaster with embedded metal and encaustic surface, 12 × 12" (31 × 31 cm), 2003.

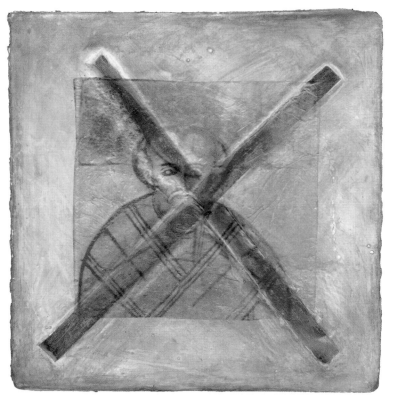

Creative Explorations

- When making white matte emulsion, use Liquitex gesso, with a bit of calcium carbonate, instead of white acrylic paint. After printing, remove the emulsion from the carrier; twist and fold to create cracks in the gesso. Then smooth out the image and apply oil paint, metallic pigment, Dorland's cold wax, or brown shoe polish, rubbing it into the cracks to create a distressed, leatherlike skin.

- Metals like copper foil are able to fit through the printer directly, but they oxidize when painted with a precoat like inkAID. Not to worry. You can still use them as glowing surfaces for clear emulsion transfers.

- You can make single-sheet emulsion transfers as large as your printer allows. If your printer is small, you can make several emulsion transfers and combine them to overcome your size limitations.

- As packaged, Bel inkjet waterslide decals only work with printers having dye-based inks. To prepare one of these decals for use with pigmented inks, apply two coats of gloss precoat, let dry, then print your image on the decal using your inkjet printer. Allow the ink to dry overnight, then spray with two coats of Krylon Crystal Clear. When dry, place the decal in a tray of water; the backing paper will slip off the decal. Carefully place the decal on a rigid polypropylene sheet; when the decal is dry, gently pull it off of the sheet. It is now ready to be used as a collage element. The decal is water-resistant, so it can be adhered with most glues.

- Emulsion transfers may be adhered to: canvas, paper, ceramic, wood; slate, rocks, tree bark, and other natural materials; handmade sculptural paper, embossed tin ceiling tiles, and other shaped metal; marble, ceramic tile, cement, and other architectural materials.

Encaustic

A hot-beeswax-based medium, encaustic is an option to consider as both glue and sealer. When applied thickly, it has a milky, textural surface. However, a thin hot-wax coating, fused into paper, creates a translucent surface. Encaustic dries immediately, yet, it can always be reheated and reworked or slightly scraped away. It can be combined with pigment or collage materials, and is highly durable, impervious to moisture, and does not need varnish or protective glass.

A printed clear emulsion transfer can be adhered to copper or copper foil.

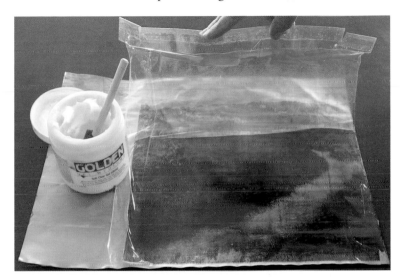

TIPS

- The surface of clear emulsion is water-soluble. You can use any oil-based or wax-based product on the surface, but acrylics and other water-based media may cause the ink in your printed image to bleed. Oils and encaustics may go over water-based media, but the reverse is not true.

- On a clear emulsion, if you want the acrylic side on top for greater protection, flip the image in your software before printing, print, and then adhere the more vulnerable print side to your surface, facedown, using UHU glue stick or non-water-soluble adhesive.

- If you use Plexiglas or other plastic instead of polypropylene, it will not release your acrylic-backed emulsion transfer. Dura-Lar will release gloss or semi-gloss precoat, but not acrylic medium or white matte precoat.

- If you do not use Krylon Crystal Clear spray to protect your image from water, brushing over curled or torn spots with a damp brush will cause the ink to liquefy.

- If desired, seal your white matte surface with a coat of acrylic gloss varnish. Or, if you prefer not to have a gloss finish, use matte spray to dull its shine.

- If you don't plan to use your emulsion transfers immediately, store them between 4-mil polypropylene sheets. Don't use Saran wrap because it will stick.

Karin Schminke
MAYNE
Inkjet print on painted and
precoated black rag paper,
diptych, 30 × 44"
(76 × 106 cm), 2002.

Bonny Pierce Lhotka
WASH DRESS
Inkjet print on polycarbonate
film layered with acrylic paint
and a second digital print,
30 × 24" (76 × 61 cm),
2002.

What's Next

With their unique properties, dry emulsion transfers can create interesting, dimensional, mixed-media artworks incorporating a wide variety of nonstandard surfaces. In the next chapter, we will explore another equally versatile process: gelatin transfers.

Karin Schminke
FIRST SNOW
Tiled clear emulsion transfers over acrylic paints surround a
lenticular center panel, 32 × 32" (81 × 81 cm), 2002.

Gelatin Transfers

THE THREE DIFFERENT PROCESSES described in this chapter were developed in an attempt to put digital images on frescolike surfaces. Fresco is an ancient art form created by pounding pigment into wet plaster, resulting in an image with a chalky, soft quality. We began with the erroneous assumption that dry plaster could absorb water in the same way that paper does when it receives a transferred image. But that was not the case, because the plaster proved difficult to rehydrate.

So we adapted a traditional fresco recipe. The ingredients—calcium carbonate, rabbitskin glue, and water—are the same as used in gesso for canvas. Artists also apply the mixture to prepare panels for oil paint, egg tempera, and encaustic.

Calcium carbonate is sold under several names in varying grades of quality. For our purposes, we use the product sold as "powdered marble." It is reasonably priced and readily available at art-supply stores. Another version is called "whiting." It is more finely ground and more expensive. Still another calcium carbonate is "athletic field marker," which is very inexpensive and coarse. The powdered marble we recommend is optimal for pouring, and creates a smooth gelatin fresco surface.

Basic Processes

Each of the following three processes for making gelatin transfers has its own special qualities. As you become familiar with them, you'll be able to select the one that best enhances the particular artwork you plan to use.

The first process creates a white, plasterlike fresco surface. The second method produces a clear gelatin, which lets the underlying surface show through. The third process creates a translucent resin panel. The underlying surface for each method must be heavy enough to resist warping. Half-inch-thick plywood is used for the white fresco; the unpolished back of a travertine marble tile is used for the clear gelatin; and half-inch-thick polypropylene is used for the removable translucent resin.

For all three processes, the digital image to be transferred is printed on a prepared transfer film, such as Océ FCPLS4, Kimoto Silkjet, or Dura-Lar. However, please note the following:

WARNING: Océ FCPLS4 is the only film recommended for transfer prints from printers with pizza wheels. The use of other films may result in tracks from the pizza wheels appearing on your work.

In addition to the three demonstrations in this chapter, you'll also find trouble-shooting tips, guidance for aligning images precisely on your fresco panel, and detailed creative explorations for transferring collaged images to surfaces.

Bonny Pierce Lhotka
WALL FLOWER
Inkjet transfer to white gelatin fresco with cloth inset, 36 × 24"
(91 × 61 cm), 1999.

MATERIALS

- protective gloves
- newspaper or plastic sheet to protect work surface
- flipped image to be transferred, printed on 12-x-12" prepared transfer film (see page 74)
- 12-x-12-x-1/2" Baltic birch plywood panel
- duct tape
- Quikrete concrete bonding adhesive
- 1 cup Fredrix powdered marble
- 1 cup rabbitskin glue, still hot (see page 30)
- double boiler
- candy thermometer
- fine strainer
- natural bristle brush

WHEN POURED ON A PREPARED PANEL, a mixture of rabbitskin glue and powdered marble cools and sets up as a fresco surface to which an image can be easily transferred. As the moisture evaporates, the gelatin hardens and thins, and the image is melded with the fresco surface. To prepare your image to be transferred, flip it horizontally in your software and print it on a 12-x-12" prepared transfer film. Allow the image to dry to the touch.

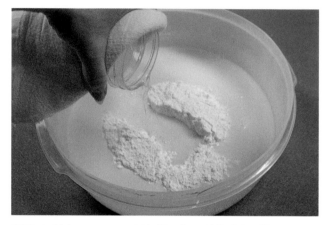

STEP 1 Make one cup rabbitskin glue. While it is still at 145 degrees F., pour it into one cup of marble powder and mix until smooth and creamy. Cool to between 75 and 100 degrees F.

STEP 2 Make a well a half-inch deep around the edges of a 12-x-12-x-1/2" birch plywood panel by pressing duct tape firmly to the panel edge to prevent leakage. Immediately before pouring the mix from the previous step, use a bristle brush to scrub a thin layer of the bonding adhesive into the panel. This lessens the likelihood of the fresco delaminating from the wood. The panel shown is taped; the surface has an adhesive coat.

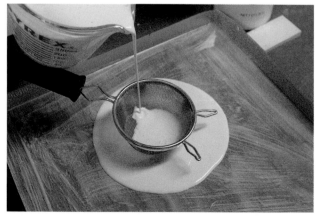

STEP 3 To remove any bubbles or other particles, pour the mixture through a fine strainer, and spread evenly on the birch panel. If necessary, tip the panel side to side to aid spreading, then place it on a level surface so the mixture will be even as it begins to harden.

STEP 4 When the surface feels like gelatin and is firm to the touch (in about one hour), cut the tape at the corner and remove it from the panel. Be careful not to tear the gel layer or lift it from the wood.

STEP 5 Roll up your printed transfer film with the image to the outside. Align your image at the edge of the panel and unroll it slowly and smoothly so that no air pockets form beneath the film. Lightly smooth the film surface by hand. Wait fifteen minutes for the moisture in the gelatin to wet the film, thus transferring the image.

STEP 6 Starting at one corner, peel back the transfer film. The image will be transferred to the fresco surface. Set the panel aside to dry. As the moisture in the fresco mixture evaporates, the Image is merged with the surface of the fresco.

Bonny Pierce Lhotka
RADISH
Transfer to white gelatin
fresco, 12 × 12"
(31 × 31 cm), 2003.

Trouble-shooting White Gelatin Fresco

TIPS

- Any leftover gelatin mixture must be discarded, since reheating destroys the adhesive properties of the glue.
- Once the liquid begins to set, you may speed gelling by placing the panel in a cool basement, an air-conditioned room, or a refrigerator.
- A cloth paint strainer or pantyhose can be used in place of a strainer.
- Resize your image to a half-inch larger than the panel to allow some play in its placement.

If you hasten drying with a fan or hair dryer, the panel will dry too fast and crack.

THIS PROCESS may need adjusting in a humid climate. As water evaporates from the mixture, it may shrink and cause the panel to warp, crack, or delaminate. To counter those problems, try the following:

- Be sure the temperature of the mixture is about 75 degrees F. Higher temperatures may cause the panel to warp.

Instead of pouring on the gelatin mixture, dipping the panel in it produces a thinner coating.

- To stop shrinkage, add more marble powder to the mixture.
- The thinner the poured layer, the less shrinkage is likely to occur, which means less surface cracking and warping. As your skill increases, use less mixture to pour thinner panels—or try dipping your panels directly into the hot mixture.

Registration

For accurate image registration, or alignment, prepare the gelatin panel and remove the tape so the surface is ready to receive the transfer print. Set it aside.

1 Create an 8" plywood alignment board with the same width as the gel panel; in our example, 8 × 12". The thickness should match that of the poured gelatin panel.
2 Unless your image has a 6" border, tape a 6" leader to one edge of the print.
3 With the leader on the alignment board, position the edge of the image so that it is precisely aligned with the edge of the board. Tape the leader in that position.
4 Roll up the transfer film so that it rests entirely on the alignment board.
5 Put the gelatin panel tightly against alignment board. Roll printed transfer film down onto the gelatin surface, smoothing to position perfectly. Once the image is rolled down, detach film from alignment board by removing tape.

This printed transfer film is in position for an aligned application to the gelatin surface.

The printed transfer film has been rolled out onto the fresco surface and untaped from the alignment board.

BECAUSE IT IS POROUS and will not warp, the unpolished back of a travertine marble tile makes an excellent base for a clear gelatin panel. Look for tiles with color patterns or variations that can become part of the image. The directions for making a clear gelatin panel are much the same as for white gelatin, with a few changes, so step-by-step photos are not repeated here—but please review and follow the adjusted instructions.

1 Make a well a half-inch deep around the edges of the marble tile by pressing duct tape firmly to the tile edge, so that no leaking can occur. Just prior to pouring, use a bristle brush to scrub a thin layer of the hot rabbitskin glue into the surface of the marble.

2 Immediately pour the rest of the hot glue through a fine strainer onto the marble panel. Tip the panel side to side to spread evenly, then place it on a level surface so the mixture will be an even thickness as it begins to set up.

3 When the surface feels like gelatin and is firm to the touch (in about one hour), cut the corner of the tape and remove it from the marble. Be careful not to tear the gel layer or lift it from the marble.

4 Roll up your printed transfer film with the image to the outside. Align your image at the edge of the marble and unroll it slowly and smoothly so that no air pockets form beneath the film. Lightly smooth the film surface by hand. Wait fifteen minutes for the moisture in the gelatin to wet the film, thus transferring the image.

5 Starting at one corner, peel back the transfer film. The image will be transferred to the clear gelatin surface. Set the panel aside to dry. As the moisture evaporates, the image is adhered to the surface of the marble.

MATERIALS
- protective gloves
- newspaper or plastic sheet to protect work surface
- flipped image to be transferred, printed on 12-x-12" prepared transfer film (see page 74)
- 12-x-12" travertine marble tile
- 1 cup rabbitskin glue, still hot (see page 30)
- duct tape
- double boiler
- candy thermometer
- fine strainer
- natural bristle brush

Bonny Pierce Lhotka
SHELF DOLL
Inkjet clear gelatin transfer to travertine marble, 12 × 12"
(31 × 31 cm), 2001.

While the gelatin is still wet, a cookie cutter may be used to cut patterns on a panel.

This print was too dry to be placed on a dry fresco, resulting in an unsuccessful transfer.

Creative Explorations

- An accidental side-effect can ruin an image, but the same effect deliberately applied can be compelling. For example, if the gelatin is cut when it has the density of Jell-O, it will split at the cut lines as it dries. A cookie cutter or other tool can be used to divide an image into shapes and patterns, sometimes exposing the base surface beneath.

- To transfer to a dried panel, spray the fresco or gelatin surface with cold water. After the water absorbs into the surface, spray it again; repeat a third time. When there are no puddle spots, place the printed transfer film facedown on the panel. First use a soft-rubber brayer to press the print against the surface, then use a plastic scraper to burnish on the back of the polyester transfer film. Continue rubbing until the amount of the image you want has been transferred. Additional images or small details can be added. The digital print must be transferred within four to six hours after printing; images that are allowed to dry longer may not rub off onto dried fresco panels.

OPPOSITE: **Dorothy Simpson Krause**
IN HIS OWN ACRE
Transfer to white gelatin fresco
with incised marks, 34 × 47"
(85 × 120 cm), 1999.

MATERIALS

- protective gloves
- newspaper or plastic sheet to protect work surface
- flipped image to be transferred, printed on 12-x-12" prepared transfer film (see page 74)
- 12-x-12-x-¹/₂" polypropylene panel
- duct tape
- 2 tablespoons Knox gelatin
- ¹/₂ cup cold water
- candy thermometer
- ¹/₂ cup Quikrete acrylic fortifier resin
- 1 teaspoon glycerin
- fine strainer

THIS PROCESS USES acrylic resin and glycerin to create a removable translucent sheet that has a gelatin surface to which you transfer your image. The result is a somewhat flexible and waterproof panel, resembling an image embedded in beeswax.

1 Wash and dry the polypropylene panel. Make a well at least a half-inch deep by pressing duct tape firmly around the edges to prevent leakage.

2 Dissolve the gelatin in the half-cup of water and let it sit and expand for five minutes. When the mixture resembles applesauce, heat (not above 140 degrees) until it becomes clear liquid.

3 With a candy thermometer, determine when the gelatin has cooled to about 100 degrees F., then gently add the acrylic fortifier resin and the glycerin.

4 Pour this mixture through a strainer onto the perfectly level sheet of polypropylene; the resin should be evenly thick.

5 When the resin has set up like gelatin, remove the duct tape. Roll up your digital print on transfer film with the image to the outside. Align your print at the edge of the polypropylene panel and unroll it slowly so that no air pockets form beneath the film. Lightly smooth the film by hand.

6 Wait fifteen minutes for the moisture in the gelatin to wet the film, thus transferring the image; peel off the film, leaving the transferred image. Let the resin dry thoroughly.

7 Gelatin is a weak adhesive; its only purpose is to create the gelatin surface. The edges of the pour will hold while drying, but there will be little or no bond to the polypropylene base, so the entire gelatin layer can be popped off.

A hand can be seen through the translucent resin in this detail.

RIGHT: **Bonny Pierce Lhotka**
DAY DREAM
Transfer to acrylic resin with iridescent pigment, 24 × 24" (61 × 61 cm), 2003.

SOME OF THE STEPS in the three previous demonstrations are incorporated into this variation, making a transfer of collaged images woven together. Begin by printing several sheets of digital images on a prepared white transfer film such as Océ FGPLF4. The white film makes it easier to visualize what the collage will look like when transferred. After printing, set the film aside for a day or two, until it is dry enough to handle.

MATERIALS

- protective gloves
- newspaper or plastic sheet to protect work surface
- image to be collaged printed on prepared white transfer film
- wet paint brush
- transparent tape
- freshly prepared white gelatin fresco panel

STEP 1 Choose your primary image, then cut an assortment of images that have been printed and are ready to be integrated into a unified composition with the primary image. Here, the primary image is the doll. Slits are made into it to accommodate interweaving other images into a collage.

STEP 2 Additional forms are interwoven into a print of the doll. With the woven collage faceup, use a small brush to place a drop of water under any overlapping areas. The precoat or transfer mixture on the film will act as glue to hold these areas together. With the woven collage facedown, tape any cut marks so that they don't flop loose as the print is laid on the gelatin. Now, roll your collage on a tube, face out; position at the edge of your prepared white gelatin fresco panel, and unroll onto the surface. Smooth the surface by hand and let sit for fifteen minutes.

STEP 3 Starting at one corner, peel back the film collage. The cut marks create a sharp edge and the illusion of dimensionality, allowing the underlying white fresco to show through.

TIPS

- You can add pearlescent powdered pigments to a clear gelatin mixture prior to pouring. Gold under a black-and-white transferred image is especially beautiful.
- If you add a teaspoon of glycerin to each cup of mixture, the fresco will dry very flat and draw up, giving a natural decklelike edge to the image.
- Consider combining more than one transfer technique; for example, a white gelatin fresco transfer with a clear gelatin transfer on a birch panel (see *Lily,* page 105).

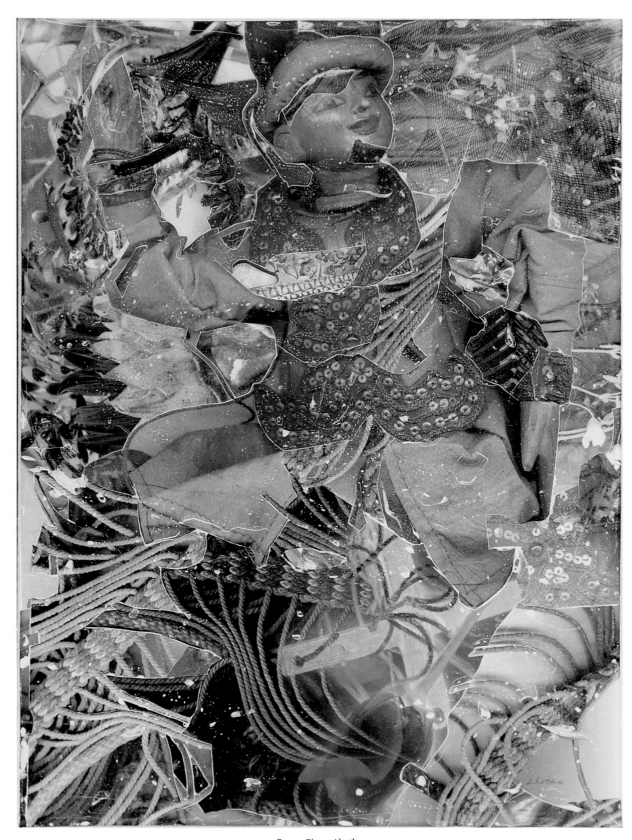

Bonny Pierce Lhotka
TRAPEZE
Woven inkjet transfer to white gelatin fresco, 32 × 24" (81 × 61 cm), 2000.

What's Next

We've covered three different ways to prepare gelatin transfers, each resulting in its own distinctive look. As always, we encourage you to have fun exploring variations and additional applications of these processes. In the next chapter, we leave the genre of image transfers to explore what is perhaps the key technique of mixed-media art: layering.

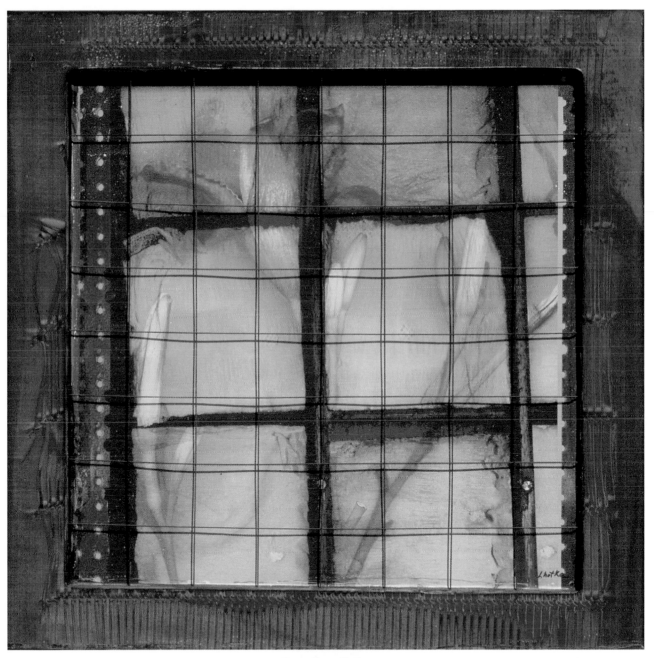

Bonny Pierce Lhotka
LILY
Woven rusted steel rods over white gelatin fresco transfer
in a surround of Baltic birch with clear gelatin transfer,
30 × 30" (76 × 76 cm), 2002.

Layering Prints with Collage and Paint

THIS CHAPTER EXPANDS, and literally builds on, the techniques covered in Part One, "Basic Processes," as you take multiple layers and sandwich them together, building surfaces that are rich in texture, color, and even luminosity—artwork that simply can't be created any other way. In effect, layering opens to you many more opportunities to influence the direction of your art as it is produced.

An artist's workflow traditionally encompasses continual consideration and revision. During the creative process, we frequently stop to ponder the next step. Periods of idea development alternate with periods of production activity. We work, look, and evaluate, responding to the surface as it develops.

With standard, single-step digital prints, the process is different. The artist deliberates during the digital development of the image, but the actual production—the printing—happens in one interval, without human intervention.

Creating digital prints in layers is more intuitive and responsive, more akin to traditional printmaking, and the slow building up of layers can result in a surface of depth and complexity. Typical combinations might consist of these three layers—digital underprint/mixed media/digital overprint; or of these three—transferred images/mixed media/digital overprint. Or you can slowly build up a print with a series of digital prints, layering one over another, over another, and so on. The innumerable variations of base media, traditional media layers, and the print itself make layering a very versatile process.

Most of the methods in this book and many traditional art techniques and materials can be integrated into layered prints, as may standard printmaking processes, such as lithography, etching, and woodblock. For instance, a white or silver silkscreen added as a final layer gives more dimensionality to a surface.

Karin Schminke
FRAGMENTS: EARLY
MORNING
Inkjet printed in layers
with collaged rice paper,
30 × 22" (76 × 56 cm),
1998.

In this detail, layers of paint with transferred and printed imagery create a strongly textured and richly colored surface.

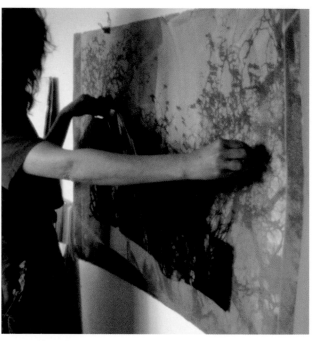

In layering prints, overlay transparencies to study your next step.

Acrylic paint and KwikPrint color photo emulsion form the underlayers of the final print of *Meditation*.

RIGHT: **Karin Schminke**
MEDITATION
Inkjet print over acrylic paint and color photo emulsion,
44 × 30 1/2" (106 × 79 cm),1996.

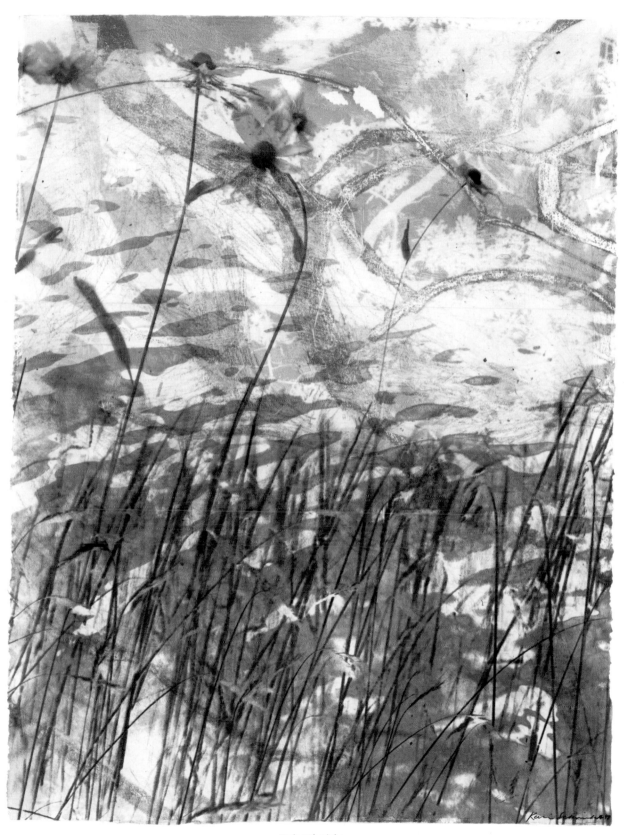

Karin Schminke
GALLIANO
Paint and rice paper layered between a transferred image and an inkjet print, 30 × 22" (76 × 56 cm), 1998.

Aligning Multiple Layers

FOR GOOD ALIGNMENT, your printer must accommodate manual loading or automatically load to the same position with reasonable accuracy. With manual loading, you open a paper release lever, align your paper, and then close the lever that grabs the paper. This gives you manual control over the position of the paper. Desktop printers generally do not allow you to position your paper manually, so "Option One" (below) is your only choice.

WARNING: Inkjet printers are not designed to register layers of printing in perfect alignment. The alignment suggestions below cannot ensure precise alignment, so plan your images accordingly.

Note "Position" and "Scaled Print Size" settings in Photoshop's Print dialog box so that you can properly align future prints.

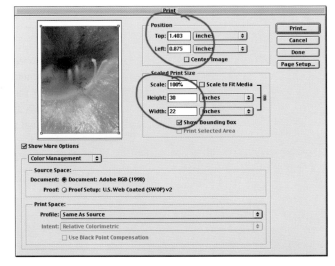

OPTION ONE: APPROXIMATE ALIGNMENT
Image layers can relate to each other without needing to align. With very little effort, you should be able to align within about a quarter-inch. To do so, create all images you plan to print just slightly larger than your final desired size. Select a paper slightly smaller than the size of your images, so that when they are printed sequentially, they will fill the entire allotted printing area. Then trim or mat your final image to the desired size, in order to remove or cover any misalignment visible at the edges.

OPTION TWO: MARK FOR REPOSITIONING
For this method, your printer must have a manual paper load lever. As you load your paper for the first layer, mark its position in pencil on the paper itself prior to closing the paper lever. Put pieces of tape on your printer to create relative marking spots.

As you prepare to print on the paper, observe and record the paper size and print size given in your software or RIP. When you are ready to print a subsequent layer, reposition your paper carefully according to the alignment marks you made earlier. Set the sizes and margins in your software to match the settings of the first print.

Misalignments are often very noticeable at the edges of an image. To overcome this problem, create full-bleed images by extending the edges of the paper with masking tape, print beyond the paper's edge onto the tape, and then removing the tape.

For images with margins, print your first image centered on the paper, and then tape up to its edge with low-tack drafting tape, which releases easily. Create all your overprint images about a quarter-inch wider in each direction. Realign your paper in the printer, and print subsequent images centered. Your subsequent images will overprint on the taped area. When you remove the tape, your edges will be perfect.

Paper is marked for repositioning in an Epson 9600, using the printer's alignment holes as relative marking spots.

For a full-bleed image, add tape to extend the paper's edge. The second image prints over the edge of the image area onto the tape.

TWO LAYERS OF PRINTED image sandwich a layer of painted elements in this process. Since the digital print layers are transparent, it is safest to build up your image layers from light to dark, saving darkest values for your final layer. If you do need to put down dark areas first, be aware that subsequent print layers can only darken any hue that has already been printed. Of course, a middle layer of light paint or collaged paper can lighten the value level of the original base print, giving you more options for your overprint.

Prepare two or more images in Photoshop for print, or prepare a single Photoshop image with two or more layers that you plan to print separately. Decide how you are going to handle alignment and edges. "Option One" on the previous page is recommended for beginners.

MATERIALS

- protective gloves
- newspaper or plastic sheet to protect work surface
- commercially precoated inkjet art paper
- acrylic paints
- acrylic medium
- soft gel medium
- pearlized or metallic acrylics
- paint brushes
- inkAID semi-gloss or gloss precoat

STEP 1 On a sheet of commercially coated inkjet art paper, print an image that will be the base layer, or underimage, of your art. In our example, note that the edges have been taped before printing the base image to ease the realignment process, as described in "Option Two" (page 110). Enhance your printed image with acrylic paint mixed with acrylic medium to thin the pigments, create a glaze, and allow the underimage to show through. Vary the amount of pigment you put down in response to the image itself.

STEP 2 As shown in this detail, use soft gel medium to emphasize brushstrokes or to add slight relief to the painted layer. Also experiment with pearlized or metalic acrylics to add luminescence to your final image. Allow your art to dry overnight, then apply clear gloss or semi-gloss precoat, and let it dry overnight.

STEP 3 Now the overprint image is ready for the printer. Referring to our earlier instructions about alignment, make sure your paper aligns correctly with your overprint, paying particular attention to how your art paper will be oriented (top or bottom first?) as it comes out of the printer.

Karin Schminke
GLAD 2 B
Iridescent gold acrylic
paint and soft gel
medium between two
layers of inkjet printing,
30½ × 22½"
(78 × 58 cm), 2003.

TIPS

- Don't stop with two printed layers. Apply more painted, collaged, and printed layers until the image is developed to your satisfaction.
- Consider how each layer's colors affects the others. Since they are so transparent, there is a strong interaction between layers, which may result in wonderful hues—or in mud—so take the time to print small samples of your base layer and test them in subsequent steps.
- Protect your completed art with Krylon Crystal Clear or other postcoat brand.

This wet transfer print was prepared as the bottom layer for *Firelight* (opposite page).

Creative Explorations

- To compose a more precise overprint design, digitize your underlying art and experiment with composition in your software prior to overprinting. Review and apply our earlier instructions (see page 65) for "Collage as Template for Digital Overprint."
- Instead of printing your base image on commercially precoated paper, use a standard fine-art paper to give a softer, less dense image.
- Or choose an inkAID precoated standard art paper as a base.
- Customized surfaces created using any of the methods covered in Chapter 2 will add even more interesting textures.
- Consider using a wet transfer print (see page 75) or even an unsuccessful wet transfer as your base layer.
- Paint or collage over unsuccessful areas of a transfer. Even a largely failed transfer image can be rescued with white matte precoat. Let small areas show through the precoat, or apply it thinly. These techniques can create a beautiful image for your base layer.
- Use acrylic medium to collage rice papers on your first printed layer. Flatten thin paper before it dries and use the slot-ruler (see page 46) to avoid head strikes.

Apply thin rice papers to a transferred image with acrylic matte medium, as shown here in preparation for *Fragments: Early Morning* (page 106).

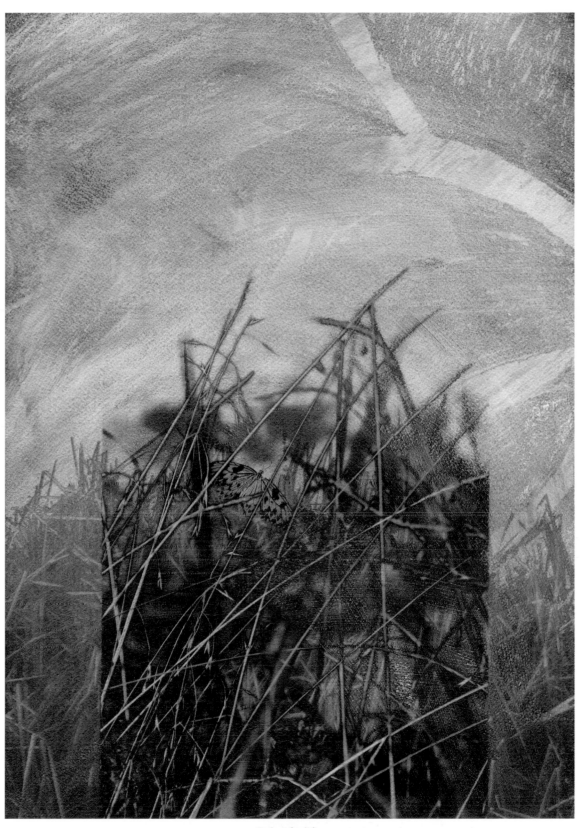

Karin Schminke
FIRELIGHT
Inkjet print on wet transfer print and acrylic paint, 30 × 22" (76 × 56 cm), 1998.

MATERIALS

- protective gloves
- newspaper or plastic sheet to protect work surface
- Arches Cover Black paper
- white pencil
- white and/or other light acrylics, metallics, water-based oils
- paint brushes
- sponge brush or bristle brush
- inkAid white matte precoat
- inkAID semi-gloss or gloss precoat

USED ON BLACK, lightfast, 100-percent cotton-rag paper, this process starts with printing a draft of an image, then painting over it with white or other light acrylic and metallic paints. When you print the original image over the painted image, there will be a striking correspondence of form. The printed-layer colors will look hand-painted through transparent inkjet overprint.

To start, create a draft image in Photoshop by making a duplicate of your image (select: Image: Duplicate) and convert it to a black-and-white image (select: Image: Mode: Grayscale). Then, in addition to following the illustrated steps below, see a variation for overprinting full-bleed edges in a related "Tips" section (on page 116).

STEP 1 Adjust your gray-scale image to high contrast (select: Image: Adjustment: Brightness/Contrast). In the dialog box, move the contrast slider to the correct level for high contrast. You can also use a high-contrast curve for the same task (select: Image: Adjustment: Curve). For alignment, "Option One" (see page 110) is suggested.

STEP 2 In the Print Dialogue Box, create a custom paper size if necessary. Include any taped edges when measuring paper dimensions. Record the Print Dialog Box settings for margins and positioning (is the image centered or not?). Print your gray-scale image on the black paper. The result will be a faint, black-on-black picture. In preparation for underpainting, you may need to place the print in good light and trace its major forms with white pencil to help you see them.

STEP 3 To create the underpainting with your printed and traced forms, use your light-value paints. The lightest painted areas will provide the greatest color saturation in the overprint. Thinly covered and unpainted areas will appear black or very dark, causing those overprint areas to be all but invisible.

STEP 4 This overprint detail reveals its transparency and how the underprint controls the overprint's values. Knowing that, create your underpainting to work in its own right, carefully planning composition, values, and brushstrokes. After overnight drying, apply clear semi-gloss or gloss precoat, let dry, then apply another coat, using a sponge brush if you want to hide brushstrokes—a bristle brush if you want the strokes to show. Let the work dry thoroughly.

STEP 5 To overprint the final image, feed your painting into the printer, making sure you orient it correctly, aligning the registration marks you made when you printed your initial black-on-black draft image. Prepare your full-color overprint image to print in Photoshop. Double check the positioning of your image in the various Print Dialog boxes to make sure their settings match the settings you used to print your original draft image—then print!

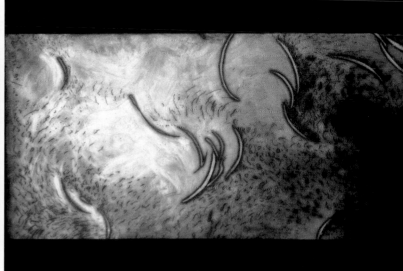

Karin Schminke
INFLUENCE
Inkjet diptych on Arches Cover Black paper, 30 × 88" (76 × 220 cm), 2003.

Creative Explorations

- As a variation, consider using white matte precoat as your underpainting; it goes on translucent, but dries chalky white. Apply it in thin, drybrush strokes for textured effects; dry between coats.

- On your underpainting layer, substitute or augment acrylics with colored pencil or other water-based media.

- Image resists, masks, or friskets can keep color values from getting too dark, and can also bring varied shapes to a composition. After overprinting your image, remove the frisket.

- Unprecoated acrylics work as nonremovable resists, as the printer ink won't stick to them. After printing, simply wipe ink from unprecoated acrylic areas.

- Expect the ink to puddle on resist areas, so don't use printers with pizza wheels with this process.

- If you have a photo or flattened Photoshop file that you would like to split for layered printing, first, duplicate your single layer, then remove dark values from one layer and light values from the other (select: Layer: Layer Style: Blending Option) for each layer in turn. To create a smoother transition, split the "blend if" triangle (in Blending Options Dialog Box) by holding the option key (alt key on Windows) as you drag on either half of the triangle. Note that Layer Style Options are not available for "background" layers.

BELOW TOP: Moving the black triangle to the right in the Layer Style dialog box removes dark values from the image.

BELOW BOTTOM: Moving the white triangle to the left in the Layer Style dialog box removes light values from the image.

TIPS

- If you want your image to be full bleed, add tape to extend the edges of your paper, and measure the new paper size. Before closing the paper release lever as you load paper in your printer, mark the taped edges for later repositioning. Review complete instructions in "Option Two" (see page 110).

- If you choose not to tape your paper's edges, simply mark your realignment positions lightly in pencil on the black paper.

- If your paper isn't rigid enough to remain straight when fed through your printer, reinforce the paper's front edge with drafting tape applied along the back of the sheet.

- If your printer cannot identify black paper, thereby giving you a false "paper out" message, cover the back of the black paper with thin white paper to give the printer's sensor something reflective to read. You may also need to turn off any printer options that sense where your paper is positioned. For printers that sense the top surface of paper, add a two-inch white paper leader to the edge of the paper that feeds first into the printer.

- A draft print for positioning an underpainting works well on white paper, especially where a more colorful and painterly image is desired.

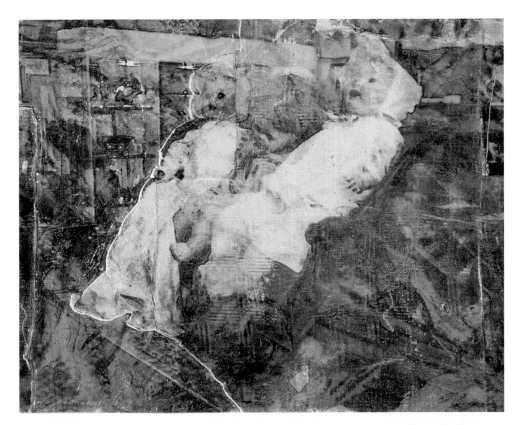

Bonny Pierce Lhotka
TEA TIME LADIES
Transfer to cloth and fresco,
with pastels, 24 × 36"
(69 × 91 cm), 2000.

Working with layers easily accommodates a wide assortment of surfaces—including very surprising ones. Here, a wet transfer to an old tablecloth was collaged with a fresco surface, embedded in additional fresco areas and embellished with pastels.

Bonny Pierce Lhotka
PAPER DOLL
Zund UV inkjet print on two sides of polycarbonate,
backed with mirror, 24 × 24" (61 × 61 cm), 2002.

Working with a service bureau gives artists access to professional printing equipment. This artwork was printed on both sides of clear polycarbonate and framed in front of a mirror to create depth and reflection.

Dorothy Simpson Krause
BOWED
Zund UV inkjet print on two sides of clear polycarbonate, with
painted tin ceiling tile behind, 24 × 24" (61 × 61 cm), 2002.

A found object, such as the ceiling tile used here, can add a distinctive, contrasting touch to layered art.

Digital and Traditional Printmaking Meet

AS ARTISTS-IN-RESIDENCE at the long-established Littleton Studios in Spruce Pine, North Carolina, founded by glass artist Harvey K. Littleton, we were privileged to work with the group's master printer, Judith O'Rourke and her staff, to integrate our new digital approaches to art with vitreography, a printmaking method that employs a glass plate.

BELOW: Bonny Pierce Lhotka inspects printed films ready to transfer.

With this method, the first step is printing digital images in reverse on clear transfer film and then transferring the images to damp paper with a press. Then, either of the following two sophisticated printing methods is used to produce a second layer of media.

Planographic vitreographs are made using a stencil of silicone over water-soluble drawing materials. After the silicone is cured and the drawing washed out, the plates are inked and printed like traditional lithographs.

Intaglio vitreographs are created by masking a surface of the glass plate with litho ink, glue, or adhered materials, and then sandblasting the exposed portions of the surface in order to abrade them. Other methods include frosting, etching with hydrofluoric acid, and grinding with diamond-tip or similar tools.

During our two-week residency, we produced a portfolio of prints, a sampling of which are shown opposite, along with photos of the three of us at work creating them.

Karin Schminke prepares a plate with lithograph ink.

Dorothy Simpson Krause makes a drawing to be used to create a planographic vitreograph.

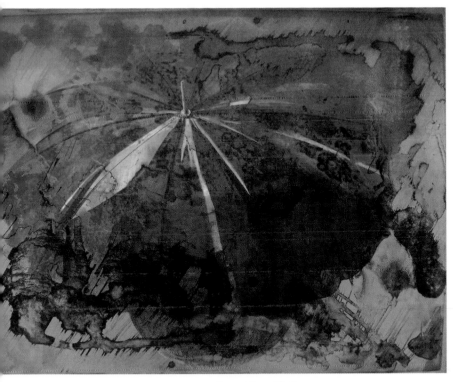

Bonny Pierce Lhotka
THUNDER CLOUD
Vitreograph on inkjet wet transfer print, 24 × 30" (61 × 76 cm), 1998.

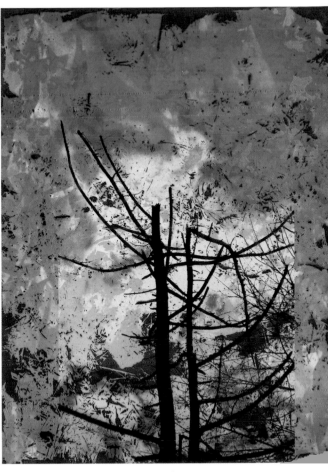

Karin Schminke
MITCHELL
Vitreograph on inkjet wet transfer print,
30 × 24" (76 × 61 cm), 1998.

Dorothy Simpson Krause
GUNSLINGER
Vitreograph on inkjet wet transfer print, 24 × 30" (61 × 76 cm), 1998.

What's Next

Layering is central to the creation of any collaged or mixed-media artwork, particularly when it incorporates digital printing. We hope that by walking you through a couple of processes, we've shown the importance of composing your work "strata-graphically," with layers in mind.

The more you work with layers, the more intuitive this type of composition becomes. As always, we encourage you to experiment, explore, and expand your creative horizons—which we certainly offer in the next chapter, as we break out of the two-dimensional plane and examine ways to create three-dimensional work.

RIGHT: **Dorothy Simpson Krause** **LUNA** Inkjet lenticular print showing movement and depth, 35 × 28" (87 × 71 cm), 1999.

OPPOSITE: **Bonny Pierce Lhotka** **JOY** Inkjet print on acrylic and polycarbonate under rusted steel rods within a surround of inkjet print on Baltic birch, 30 × 30" (76 × 76 cm), 2002.

Layering transparent media gives the viewer a look through several layers, creating a sense of depth and drama. Here, four layers of precoated polycarbonate were printed and then sandwiched together before being framed in a digitally printed surround.

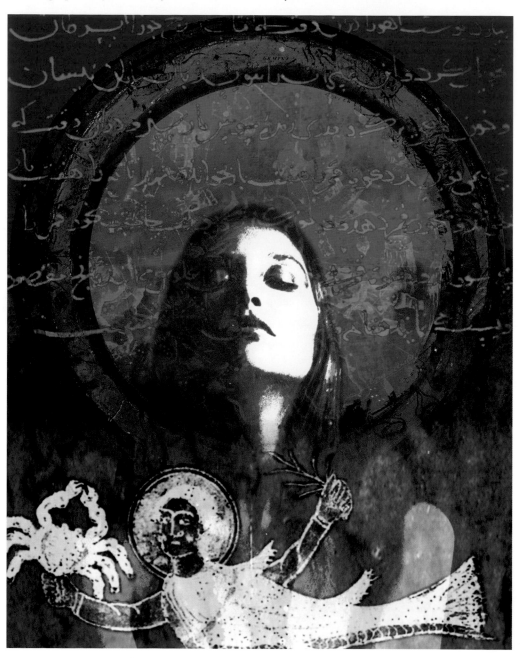

Creating Three-Dimensional Work

PUSHING IMAGES INTO A THIRD DIMENSION, literally moving them off the wall, the projects in this chapter combine digital printing with three-dimensional surfaces, elements not usually associated with each other. Printing on, or transferring to, dimensional surfaces can imbue your images with heightened physical presence, displayed in various ways. For example, *Name of the Mother* (opposite), a wet transfer to two large, shaped copper pieces, can either hang or stand, and as with sculpture, more than one surface may be viewed. By applying images to multiple surfaces, you can create complex constructions. Irregular shapes, like kites or pinwheels, can be made by printing on translucent vellum or both sides of aluminum or other stiff material, then cutting and shaping it so that the image can be seen from both sides.

Simple ways of working dimensionally include adding materials such as nails and wire to give low relief to a print, working on unusual found surfaces, and setting images into surrounds of other material. Some materials will even cast shadows, creating yet another layer of dimensionality.

An even greater physical presence can be created when working on an architectural scale. When digital printing is combined with outsized and/or multidimensional surfaces, the creative possibilities are vast and always expanding as new techniques and technologies emerge. For example, numerous large, individual panels can be printed and hinged together to form a huge folding screen. The lenticular image introduced on the next page is another innovative option.

It is now possible to create multidimensional objects directly with specialized digital printers. Printers using a powder-binder technology build solid objects layer-by-layer, alternately printing thin layers of powder and binder in an additive printing process. Milling machines, designed to be subtractive devices for proto-typing, let artists carve three-dimensional forms into a wide range of materials, including wood, aluminum, brass, and copper. Other printers use lasers to cut out vinyl for installations and cardboard that can be scored, folded, and assembled into three-dimensional structures. Flatbed printers may print directly on surfaces up to twelve inches deep. These processes require specialized, expensive equipment that is beyond the pocketbooks of most artists, as well as beyond the scope of this book. However, you may be able to access some of it through a service bureau—and on you own, you can certainly continue to explore the many ways of using standard inkjet printers to enliven your work with dimensionality.

Dorothy Simpson Krause
NAME OF THE MOTHER
Inkjet transfer to
copper diptych,
44 × 38 × 3 1/2"
(106 × 96 × 96 cm),
2002.

Lenticular Images

IMAGES THAT APPEAR to have actual depth and movement on a two-dimensional surface, lenticular devices use specialized prints and lenses that combine to create remarkable visual effects. Popular culture was first exposed to lenticulars in the form of Cracker Jack prizes that flip between two images as you turn them in the palm of your hand. Recent innovations in computers and related technology make it possible for artists to create lenticular images up to four-by-eight feet, using inkjet printers.

We are proud to have pioneered applying this fascinating and complex technology to fine art, creating works that appear to jump off the wall. The three-dimensional images we create in our studios can have an apparent depth equal to the width of the image, often projecting forward as far as twelve inches. Unfortunately, the photo reproductions here cannot convey the depth and movement of lenticular works, so we hope that at some point, you will have occasion to see originals of this extraordinary art form.

Bonny Pierce Lhotka
LEAPING LIZARD
Two-sided inkjet lenticular print,
with inkjet transfer to Baltic birch
plywood base, 36 × 36 × 14"
(92 × 92 × 36 cm), 2000.

This freestanding artwork has a wooden base supporting a two-sided lenticular image that creates the illusion of both animation and a sphere projecting in front of the lens.

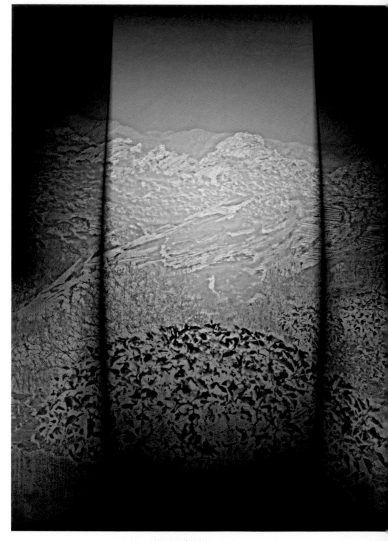

Bonny Pierce Lhotka
HILL TWO
Inkjet three-dimensional lenticular print, 60 × 45" (153 × 115 cm), 2003.

A monolithic landform image is created from scanned and photographed images and processed to create an illusion of sculpted sandstone.

In addition to depth, animation sequences can be captured by lenticular imaging, allowing an object to move, change colors, and/or morph into another image. The viewer sees a rapid sequence of "frames," resembling a short animation. As the eye moves past the images, the series of frames plays out one at a time. In this sense, lenticular art can be thought of as a viewer-activated animation.

Lenticular prints provide a means for artists to integrate both dimensional illusions and motion with traditional art materials. Several such examples are shown in these pages, but again, our intent is just to make you aware of the process without demonstrating it, since it is a complex process requiring highly specialized equipment not within the realm of this book's instruction. Resource information, however, is included at the back of the book for your future reference, should you want to learn more about lenticular art.

ABOVE: **Dorothy Simpson Krause**
MARKING TIME
Inkjet lenticular print with lenticular clock overlay, 28 × 28"
(71 × 71 cm), 2000.

This image has depth, shifting color, and an animated clock with hands that seem to spin as the viewer passes by.

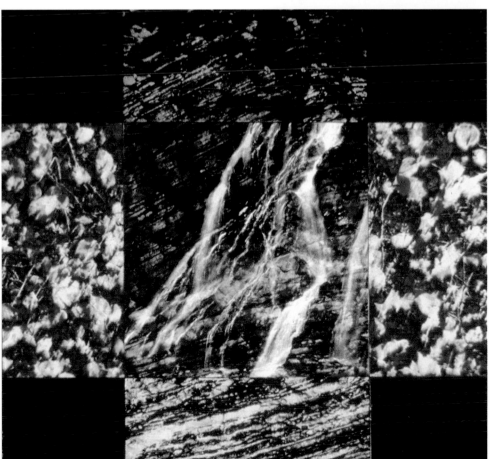

LEFT: **Karin Schminke**
CASCADING WATERS
Inkjet lenticular print, paint, and dry emulsion transfers, 32 × 32" (82 × 82 cm), 2002.

Here, elements from within a three-dimensional lenticular image have been extended into the surrounding tiles as transfers on painted panels. This repetition of form between the two-dimensional surfaces and the lenticular section enhances the sense of space in the art.

Off-the-Wall Art

THREE DEMONSTRATIONS FOLLOW: an accordion-fold book; a basket; and a suspended banner. Other ideas for combining digital and traditional materials to produce dimensional, off-the-wall art are also presented in the photos of our projects here and on the pages ahead.

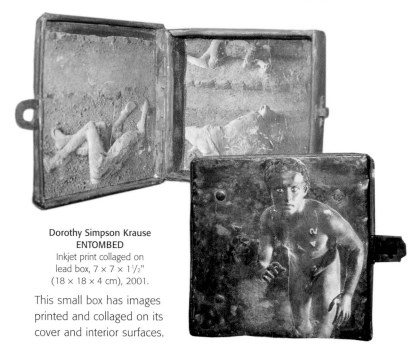

Dorothy Simpson Krause
ENTOMBED
Inkjet print collaged on
lead box, 7 × 7 × 1¹⁄₂"
(18 × 18 × 4 cm), 2001.

This small box has images printed and collaged on its cover and interior surfaces.

Karin Schminke
TREES
UV-cured inkjet print on glass, 8 × 8' (2¹⁄₂ × 2¹⁄₂ m), 2002.

This framed glass panel acts as a transparent wall.

Dorothy Simpson Krause
LAMENTATIONS
Inkjet print collaged to
hinged book board with
encaustic, pewter symbol,
and cloth hinges,
6³⁄₄ × 6" (16 × 15 cm)
closed, 6³⁄₄ × 12"
(16 × 30 cm) open, 2002.

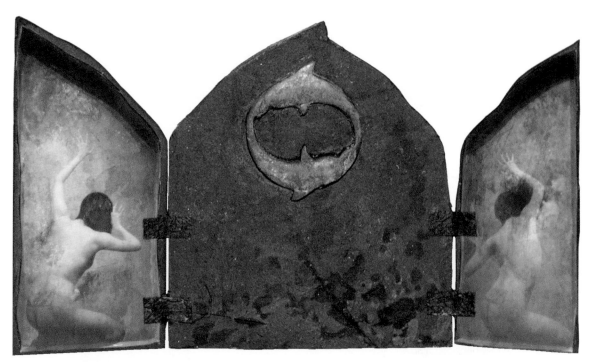

BOOK FORMS LEND themselves nicely to digital processes. Simple triptychs or scrolls afford imaginative ways to present art and ideas. An accordion, or concertina, book can be printed on one or more pieces of paper and folded. Open, it stands on its own for presentation. Since you print on only one side of the paper, it's a good introduction to three-dimensional forms, and its relatively small scale makes this project ideal for desktop printers.

Prepare an even number of identically sized images for the book's pages (our example uses eight 4-×-4" images), plus two more images of the same size for front and back covers. Open a Photoshop file the height of one image (4" in our example) and the width of all ten images combined (4 × 10" = 40" wide). Select: View > Rulers and View > Snap to > Guides. From the ruler on the left, drag guide markers and position them every 4".

MATERIALS
- paper for printing
- scissors or X-Acto knife
- ruler
- YES paste
- glue brush
- bone folder, table knife, or popsicle stick

STEP 1 Using Copy and Paste, position the book's front-cover image/text in the first block, the page 1 image in the second block, and so on, finally pasting the book's back-cover image in the last block. Select: Layer > Flatten Image. If your printer can handle the length of your book in one piece, and you have paper that size, select: Image > Rotate Canvas: 90 degrees, save your file, then print. If your printer cannot handle your book's length, divide it into manageable lengths, print each separately, then combine. Select: Image > Duplicate several times to accommodate the number of sections you will print; crop each as needed, then save and print each section of the book, rotating if necessary. Assuming you printed on two sheets, leave an inch on either the first or second sheet to serve as a hinge, paste the two pieces together and trim the printed book to your final dimensions.

STEP 2 If the divisions between pages are not clearly visible, measure and mark them for folding. Score along the fold lines by firmly pressing with a bone folder, blunt edge of a table knife, or a popsicle stick. Scoring will help you make a crisp, straight fold.

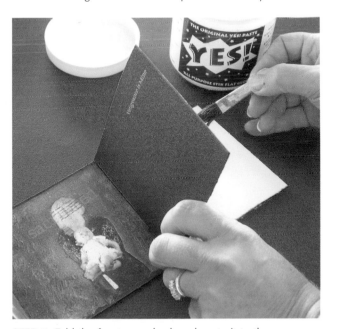

STEP 3 Fold the front cover back and paste it to the reverse side of page 1. Fold the back cover and paste it to the reverse side of the final page. Form each of the other panels into an accordion fold, making sure that your edges are aligned.

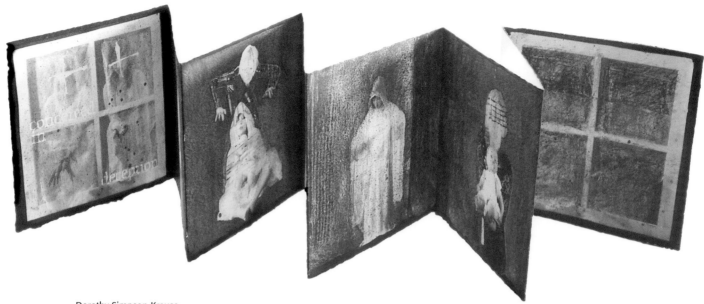

Dorothy Simpson Krause
VENGEANCE IS MINE
Accordion-fold book on Arches
Bright White paper with lead-wrapped
wood covers, 4$\frac{1}{2}$ × 4$\frac{1}{2}$"
(11 × 11 cm) closed, 4$\frac{1}{2}$ × 40"
(11 × 102 cm) open, 2002.

RIGHT: The cover for *Vengeance Is Mine* is made of lead wrapped around wood with a copper ornament. It is 4$\frac{1}{2}$" square to overlap the printed pages slightly.

A black Magic Marker touches up edges and other spots that show cracks when the paper is folded.

TIPS

- Many desktop printers will print up to 44" in length. Check to see what length image your printer can handle.
- You may vary the papers within a book for added eye appeal, but it will require more seams or different binding methods.
- Many bookbinders use a mixture of $\frac{1}{2}$ PVA glue and $\frac{1}{2}$ methyl-cellulose for adhering surfaces.
- If necessary, add a little water to YES paste to keep it moist when stored. Put a small brush or popsicle stick in the jar for spreading.
- If you display your open book standing, a heavy art paper will support itself more easily than lightweight paper.
- Reinforce books made of thin paper by inserting cardboard between the front cover and first page, and between the back cover and final page as you glue them together.

Dorothy Simpson Krause
HOUSE OF WORSHIP
Inkjet print on vellum over board
with nails and wire, 16 × 24"
(41 × 61 cm), 2002.

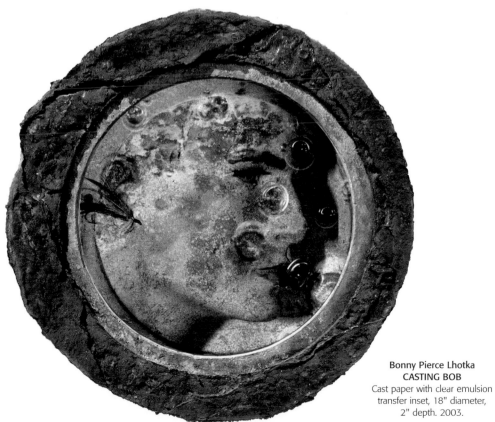

Bonny Pierce Lhotka
CASTING BOB
Cast paper with clear emulsion
transfer inset, 18" diameter,
2" depth. 2003.

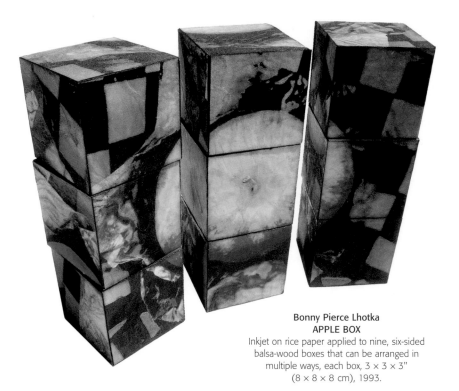

Bonny Pierce Lhotka
APPLE BOX
Inkjet on rice paper applied to nine, six-sided
balsa-wood boxes that can be arranged in
multiple ways, each box, 3 × 3 × 3"
(8 × 8 × 8 cm), 1993.

Creative Explorations

- Wrap book board or wood with soft paper, cloth, leather, or metal to create a hard cover.
- Try small-scale or large-scale sculptural and architectural variations on simple book forms: pop-up books, tunnel books, and triptychs. Print books on a single page and fold them into origami-style forms. A simple example is a folded map.
- With a digital camera, take pictures in quick succession and create a sequential "animation," or "flip," book.
- Use traditional media, transfers, or collage techniques before or after printing book pages.
- Explore ways to combine text and image, both on the computer and after the image has been printed. Consider using different fonts and font sizes, stencils, rub-on and stick-on letters, rubber stamps, and handwriting. Print on or transfer to traditional or digital letterpress text.
- Closely related to books, boxes have both depth and multiple surfaces on which to apply images. They may be wall-hung or placed on shelves or pedestals and displayed open or closed.

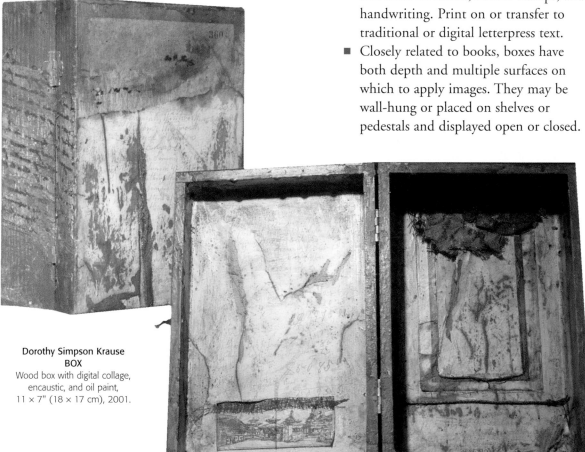

Dorothy Simpson Krause
BOX
Wood box with digital collage,
encaustic, and oil paint,
11 × 7" (18 × 17 cm), 2001.

WEAVING IS A SIMPLE WAY to use cut strips of printed images to make a three-dimensional form. If you want both the outside and inside of your final form to be seen, print on both sides of your paper, or glue two images together. Since the image will be cut into strips and reassembled,

previous, unsuccessful prints make good source material for this process. In our example, light- and dark-colored versions of the same image were glued together, giving the inside and outside of the basket opposing patterns. Print on a soft paper for easier handling during weaving.

MATERIALS

- paper with printed image
- X-Acto knife
- cutting board, preferably with grid
- thin, flexible wire
- soft cord, yarn, or raffia

STEP 1 Cut a print into strips. A cutting board with a grid pattern will help keep the strips even. Place five wires across one another in a radial pattern to create a structure, or "warp," of ten wires. At the intersection of the wires, tie on and begin to weave your soft base material (cord, yarn, or raffia) over and under the wires, working outward around the circle.

STEP 2 After enough weave is completed to hold it, add another piece of wire half the length of the others, making eleven wires so that the warp weaving will interlock as it progresses.

STEP 3 As you continue weaving and the intersection of the wires opens enough to accommodate a wider, less flexible material, change from your soft base material to your painted paper strips.

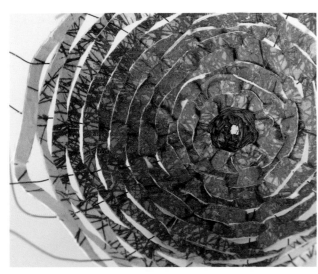

STEP 4 If you choose to expand the shape into an open, wide bowl, as shown in this photo of the inside of the basket, add more wires (maintain an odd number) to keep your weaving consistent.

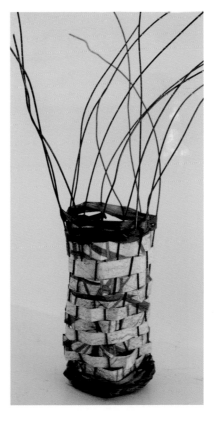

STEP 5 For a narrow basket, keep the bottom flat to the desired diameter, and then bend all the "warp" wires up 90 degrees, to start the sides. When the weaving is complete, the wires can be left long, trimmed, twisted together, or integrated back into the basket structure.

DEMONSTRATION: Suspended Banners

MATERIALS

- commercially precoated banner material
- push pins, staples, weights, rods, grommets, and/or other installation items
- needle and thread

SHEER FABRIC SUSPENDED in space makes an impressive architectural statement, especially in multiples. Light passes through the fabric, the air moves it slightly, and shadows are created both by the fabric and the image printed on it. If the fabric hangs low enough, it can act as a screen and/or barrier, directing the flow of traffic.

There are many banner-type fabrics precoated for inkjet printing: cotton, polyester, polyolefin, polyethylene, vinyl scrim, silk, and combination materials. Their weight, softness, and transparency vary significantly. You can even use uncoated material or precoat your own, although this may be impractical for large-scale pieces.

STEP 1 In planning suspended banners, draw a floor plan and elevation to position the width of the panels in relation to walls and traffic patterns. Also, taking a digital photo of the installation space is a good way to plan and visualize your ideas.

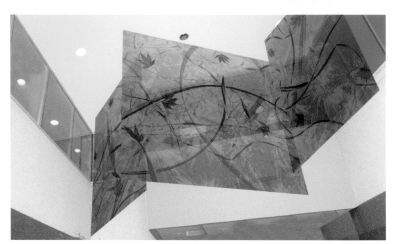

STEP 2 Decide on the size you would like your banners to be. If more than one fabric width must be put together, allow for seaming. In our example, the two flanking banners are 10 × 8' (3 1/4 × 2 1/2 m); the center banner, 10 × 12' (3 1/4 × 4 1/4 m). If your banners need bottom weights to keep them straight, allow enough fabric for hemming, and for any grommets or hanging rods. Print your image on the precoated banner material.

Karin Schminke
BANNERS
Service bureau solvent inkjet print on scrim, 10 × 28' (3 1/4 × 9 m), 2003. Collection, Brandywine Realty Trust, King of Prussia, Pennsylvania; photo courtesy MkM Fine Arts.

Because of their size, transparency, and to avoid seams, each of these banners was printed in one piece.

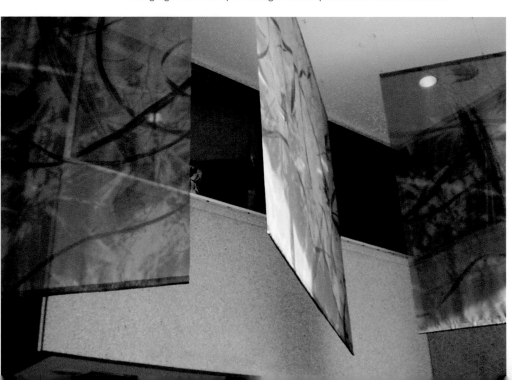

Creative Explorations

- Use fabric to alter an installation space by tenting the ceiling, stretching fabric from wall to wall, or creating standing room-divider screens.
- To make a folding screen, transfer images to hollow-core plywood doors and hinge together—or create a translucent room divider by stretching sheer fabric on open frames hinged together.
- Print on multiple sheets of transparent/translucent material, spaced for display. The layering creates fascinating visual effects between the images, the materials, the edges, and the shadows. Ideal materials include scrim, sheer fabric, and sheets of film or Plexiglas.
- Wrap printed images around simple forms such as boxes and lampshades.
- Use found architectural pieces. For example, print on translucent film, then place it on the panes of an old window.
- If you use a service bureau that works with liquid-metal coatings, you can apply real metal to any surface, creating low-relief artwork.

Dorothy Simpson Krause
BEHIND GLASS
Inkjet print on translucent film behind old wooden window, 28 × 32" (71 × 82 cm), 2003.

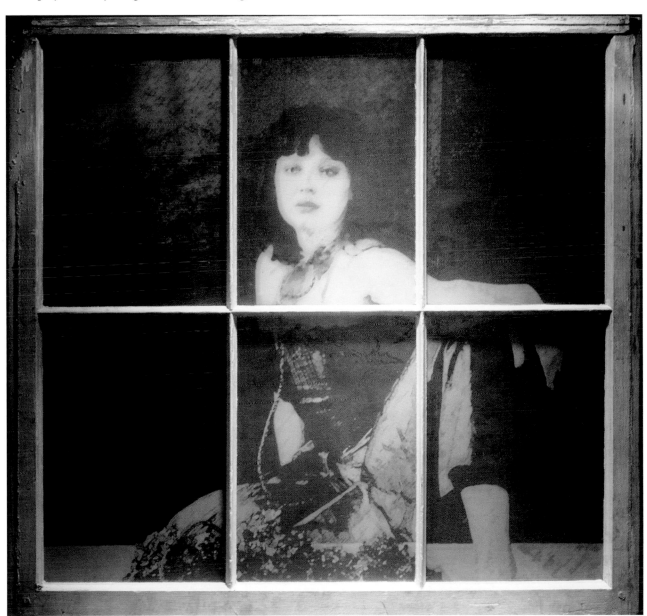

What's Next

As we have shown, there are numerous ways to incorporate digital printing into dimensional art. This unusual combination offers unlimited opportunities for experimentation. The aesthetic challenge is to compose your work so that your digital images create synergy with the dimensional spaces they occupy. Ahead, in our final chapter, we explore in detail printing on fabric, presenting stimulating ideas for transforming your work into art that is not only unique, but may also be wearable.

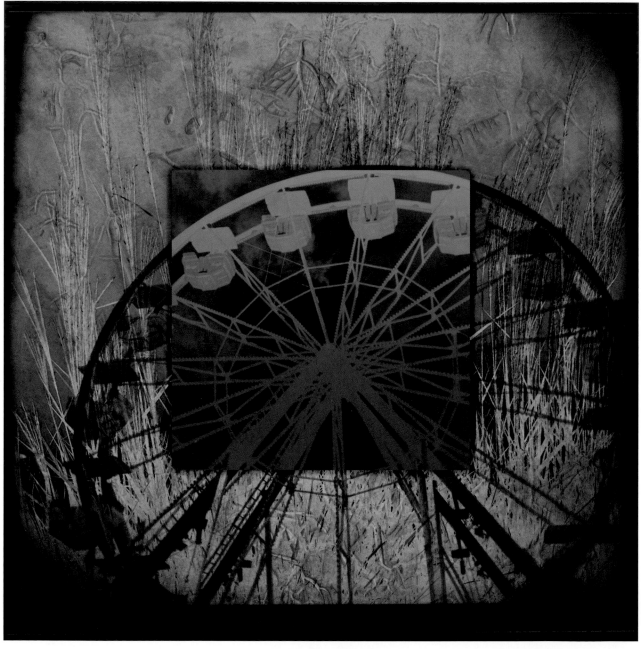

Bonny Pierce Lhotka
COUNTY FAIR
Inkjet print on custom surface in surround of inkjet print
on liquid metal, 24 × 24" (61 × 61 cm), 2003.

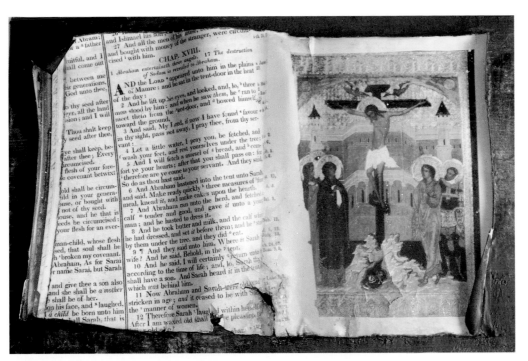

Dorothy Simpson Krause
PAGE FROM THE BOOK
Inkjet transfer to white gelatin fresco,
shaped while drying, 16 × 24"
(41 × 61 cm), 2002.

BELOW: Dorothy Simpson Krause
TRINITY PLACE
Inkjet prints on vinyl laminated
to board; twenty 4 × 8'
(1³⁄₄ × 2¹⁄₂ m) panels; total size,
8 × 80' (2¹⁄₂ × 25 m), 1998.

These hinged panels celebrated
Boston's Avenue of the Arts,
while masking a construction site.

Printing on Fabric

WHEN WE THINK OF PUTTING IMAGES ON FABRIC, the first thing that comes to mind is probably iron-on T-shirt transfers. But images may be printed on silk, cotton, linen, and synthetic fibers for all kinds of fine custom clothing, handbags, screens, quilts, and many other uses. From hand-painted Asian silks to wax-resist Indonesian batiks, fabrics have long been enhanced with dyes and pigments. Creating yard goods for wearable art and incorporating printed fabric into other art-making processes is more exciting and rewarding than ever.

In the past, images were traditionally applied to fabric with dyes by using resist techniques, dipping, or painting. Now, using inkjet printers, we can create art on fabric in ways that were previously impossible. Inkjet textile dyes are available for several brands of inkjet printers, and with additional steps after printing, or post-processing, the fabrics can be made washable.

In addition to employing textile dyes, you may also print on fabrics with standard inkjet pigment inks, which are more permanent than dyes and quite suitable for fabric-based art. Conventional methods of applying pigments to fabric are silk screening, block printing, and lithography. Now, with advances in fabric precoating, we can add inkjet printing to that list. Unlike washable fabrics mentioned above, inkjet pigment prints on fabric are stiffer and not washable, but they are appropriate for other, nonwearable fabric-based art.

Because post-processing can be costly and requires extra time, digital fabric-printing technology has yet to be widely accepted in the commercial textile industry. But soon we expect to see the growth of mass customization, whereby garments, wallcoverings, bedspreads, and other items will be custom-produced in response to individual preference. Thus, a given design may be varied with every printing so that a single pattern may yield very different products. This approach cuts production costs as it uses less ink by printing only the shape of the pattern pieces needed. It also cuts inventory costs because items are printed when ordered and shipped directly to the customer, eliminating the need to maintain inventory.

Although inkjet textile technology is still in its infancy, artists producing custom clothing are often willing to deal with issues that would bottleneck mass production. If selling apparel art interests you, by mastering a technology that has yet to be adopted by industry, you can offer one-of-a-kind textile creations at higher prices, thus justifying a process that can be quite time-consuming.

Dorothy Simpson Krause
JOANNA'S WILL
Inkjet print on satin polyester with gold leaf, 47 × 34"
(120 × 87 cm), 1999.

Basic Components

With disperse dye/sublimation, a digital file is printed on high-quality inkjet paper, then applied to fabric with pressure and heat. A heat press and the printed images ready to be transferred are shown here.

The colors of the printed image and the transferred image differ considerably. Compare the image before transferring (left) to the center image of the color proof (right) to see how color becomes brighter when transferred with heat.

THE OPTIONS for digital printing on fabric are extensive, as are the ways in which you can incorporate printed fabrics into your artwork—and wardrobe. Although custom-made wearable art is costly and exacting to produce, we find the unique results well worth the effort. If the pages ahead inspire you to try your hand at it, first, familiarize yourself with the choices to be made among the three components that go into this art form: inks, printers, and fabrics.

Inks

Inkjet pigment inks used on fabrics are the same as those used for printing on paper. They can be obtained from printer manufacturers and many third-party distributors. Fabric-dye inks for inkjet printers are a specialty product, more difficult to find; Jacquard and Lyson are two of the largest sources for them. To change your printer from inkjet pigment to textile-dye inks and back again, the inks in the printer must be drained and the printer flushed with specially formulated cleaning fluids. Artists who use dye regularly often dedicate a separate printer to that particular inkset.

Inkjet textile printing uses four different ink technologies: acid dyes, reactive dyes, disperse dyes (sublimation), and pigments. Each has a different strength and purpose.

ACID AND REACTIVE DYES

Most washable inkjet yard goods are printed with acid dyes or reactive dyes. Acid dyes used on wool, nylon, and silk are more brilliant than reactive dyes on cotton and cotton-polyester blends. Prior to washing or wearing, both acid and reactive dyes must be post-processed with steam to set their color. Both dyes fade in light, so they are generally not used for fine art where archival qualities are desired.

DISPERSE DYE/DYE SUBLIMATION

With this process, the image is printed on paper first, then transferred to fabric via a heat press, causing the dye to form a gas that is infused into the fabric. Disperse/dye sublimation only works on fabric that is at least 65-percent polyester. Images that are bright in color and as sharp as high-resolution inkjet prints are produced. These dyes are available for some Mutoh, Encad, and Epson printers. Artists who do not own the necessary printer and heat press may turn to a service bureau for this process.

INKJET PIGMENT

You can print inkjet pigment on many tightly woven fabrics without a precoat (although a precoat improves the image quality). Dry ironing pigment-printed fabric helps make the image water-resistant, but you still can't wash it in detergent. Currently, inkjet pigments are being developed for washable yardage that will require no post-processing other than ironing.

Printers

You can print on fabric using older, discontinued, or obsolete printers, since 300-dpi resolution is adequate for many textile applications. Old printers may even be preferable, since newer models usually have chipped ink cartridges that inhibit them from using third-party inks. (Some third-party ink manufacturers have developed ways of bypassing the chipped cartridge.) Bulk, or continuous, ink systems are preferable, since they are more cost-effective in terms of ink.

RIGHT: Heat-activated dyes are waterproof and applicable to many surfaces. Top, four images are printed on ceramic tiles; below, on polyester-fabric quilt squares.

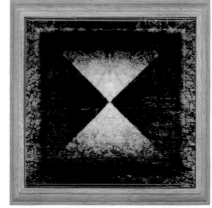
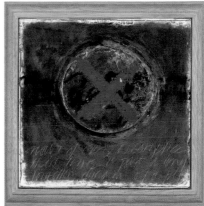
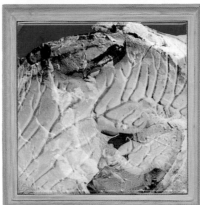
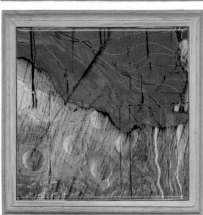
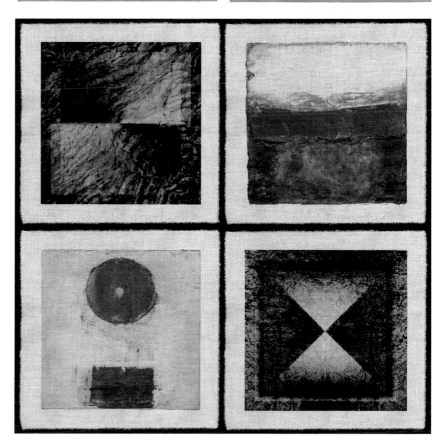

This layout for printing a vest shows the digital file pattern. Printing costs are reduced because less ink is used by printing only the shape of the pattern pieces needed.

Good used printers for fabric printing include the Epson 3000, the Encad Novajet Pro series, and the Mutoh Falcon 6000 series. Each supports "unchipped cartridges," which allows the use of third-party, fabric-dye inks. The Epson 3000 has a flat feed from the back and can print images 17" wide by 44" long. Used Encad printers 36" and wider have bulk ink systems, and you can purchase a calibration kit to adjust the print heads to their highest tolerance. (DuPont Fusion pigment ink works well in the Encad for fine art on fabric.) Mutoh makes piezo printers with 2880 dpi, supporting media 84" or wider.

Fabrics

A wide selection of pretreated, print-ready fabrics with paper backing may be obtained from Jacquard, 3P, DigiFab, and Color Textiles. These precoated textiles will work with inkjet pigment and/or inkjet textile dyes, and are available for several different printer sizes, including desktop models.

These two reversible vests, printed from the same pattern on silk, demonstrate customized design.

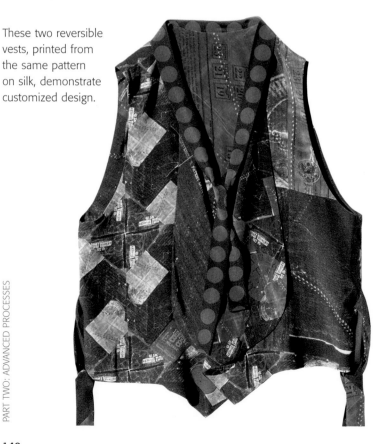

Make sure the prepared fabric you've bought is properly mounted on its paper backing. The fabric's grain should be parallel to the paper's edge. To test that, print a thin line across the entire width of the material. Remove the paper backing and tear the fabric parallel to the printed line. Some degree of off-grain alignment between the printed line and the torn edge is to be expected, but if the grain is badly off, return the yardage and ask for a replacement. In this regard, note the following:

WARNING: Before purchasing your fabric, ask the supplier about its return policy on this issue. Material mounted off-grain is useless for printing images designed to match and flow across seams.

PRECOATING YOUR OWN FABRICS

Pretreated, mounted fabrics for textile printing cost much more than yardage found at your local fabric store. You can precoat your own fabrics to use with pigment inks. However, at this writing, there are no fabric precoats for acid or reactive dyes, although such products may soon become available. On the market now are precoats for pigment ink made by inkAID and Bubble Jet Set 2000. While inkAID precoats strengthen colors, they make the fabric stiff, so use them only for artwork, not for apparel fabrics. Bubble Jet Set 2000, developed for small-format prints, is a precoat made exclusively for cotton and silk fabrics, and leaves them pliable.

Select smooth material with a tight weave. Because most fabrics are too floppy to feed through most printers, they need to be mounted to a paper backing. The thickness limitations for fabric are the same as for any other material that feeds through desktop or wide-format printers.

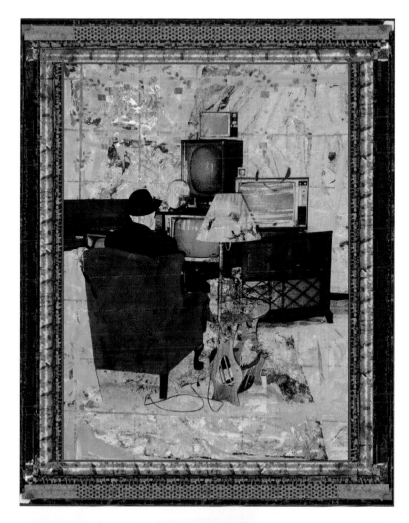

The digital collage *Silent Bob Remote Control* (above) was used as a repeat pattern for inkjet-printed yard goods, from which *Bob's Shirt* (left) was sewn.

Basic Processes

TEXTILE DYE AND INKJET pigment are the two primary colorants used to print on fabric. Both are introduced in the demonstrations that follow. The first uses inkjet textile dyes and commercially prepared fabric to create a wash-and-wear garment. The second uses standard inkjet pigment ink to print an image on fabric patterned with rust and precoated. The latter process produces fabric that can be transformed into art or sewn into a wearable (albeit unwashable) garment.

Some art clothing—such as the handbag and scarf shown below—can be printed with pigment ink and have a long life without having to be washed or dry-cleaned. Desktop printers that can handle lengths up to 44 inches are perfect for such apparel projects. Also illustrated below are two examples, a quilt and a shawl, of how an image can be printed in various ways to produce different kinds of textile art.

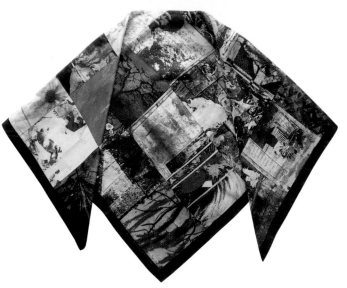

Karin Schminke
REVERSIBLE SCARF
Printed with pigment ink, the piece at top is folded and seamed to create a reversible scarf with optional collar, 60 × 5" (154 × 13 cm). 2000.

Called *heARTland,* this image is printed on velvet as a throw (top) and on silk as a square shawl (above).

Bonny Pierce Lhotka
FLOWER BAG
This handbag with long shoulder straps is printed with pigment ink on cotton, 13 × 15 × 6" (33 × 38 × 16 cm), 2000.

USING PAPER-BACKED, pretreated fabric and textile-reactive inkjet dyes, we can create a wearable work of art. First, a large acrylic painting is scanned and mapped onto a scanned garment pattern. The image is printed, post-processed, steamed, and sewn into a long coat, resulting in a handsome, one-of-a-kind garment.

When you install textile dyes for inkjet printing in your printer, follow the manufacturer's directions carefully. If you must remove a different inkset prior to installation, use cleaning cartridges designed for the removed inkset. Scan your garment pattern full-size at 100 dpi. If too large for your scanner, cut the pattern into smaller pieces, scan, and reassemble it in Photoshop (or have it scanned at a blueprint shop to full-sized gray scale). Create a new Photoshop file the width and length of your fabric. To keep your image inside the selvage area, place guides an inch from each side.

STEP 1 Arrange your garment pattern pieces in your Photoshop file, ensuring that the grain of your actual fabric will be parallel to the grain arrows on the garment pattern when you print. In our example, we began by laying out the pattern to be printed on 42"-wide silk fabric. Create the digital image to be printed; for textiles, 100 dpi at full-scale is sufficient resolution.

MATERIALS

- reactive textile dyes for inkjet printers
- scanner
- garment pattern
- paper-backed, pretreated fabric
- scissors
- steaming tissue
- cardboard tube
- steaming box
- precautionary fire extinguisher
- baby shampoo
- cotton terrycloth towel
- iron
- sewing machine

STEP 2 In Photoshop, align your digital image (in one layer) with your garment pattern (in a separate layer), leaving about three inches of blank area at the top of the file. Copy a few test sections from the rest of your images and paste them in the blank area. This provides a place for the inks to begin flowing during printing.

STEP 3 Most silks will shrink an inch for each yard during steaming. To compensate for shrinking, resize your image; for example, resize 42 × 36" to 42 × 37". (You might have to steam a test yard beforehand to see exactly how much fabric will shrink.) Then, in Photoshop, select: Image: Image Size. In that dialog box uncheck the Constrain Proportions box; check the Resample Image box, then enter your desired dimensions and click OK, which will stretch your digital image.

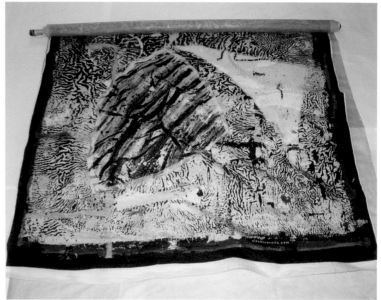

STEP 4 Before loading the fabric in the printer, carefully trim loose threads from the edges, then print your garment image on the fabric. In our example, a Mutoh printer is used. Note that pattern pieces have been rearranged to fit the fabric, and colors have been altered.

STEP 6 On a flat surface, place steaming tissue under the length of the fabric. Roll both fabric and steaming tissue around a cardboard tube to prevent the fabric from touching itself. If fabric layers touch during steaming, the dye will bleed.

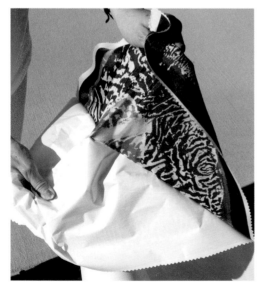

STEP 5 After the ink is dry, peel the paper backing from the fabric. Cut the fabric into lengths no longer than two yards.

STEP 7 Fill the bottom of a stovetop steaming box with two quarts of water; bring to full-boil, then reduce to simmer. Place the roll of fabric on the supports within the box and steam for one hour per yard to set the dye. Unroll the fabric immediately when steaming is completed. At high altitudes, reverse roll the fabric and steam for an additional hour.

WARNING: Care must be taken with fabrics near an open flame; keep a fire extinguisher near your stove.

STEP 8 Fill a washtub or sink with cold water, add several capfuls of baby shampoo, and immerse the fabric in the water. Wash and rinse the material thoroughly until all excess dye stops coming out of the fabric. The shampoo will keep excess dye from adhering to the yard goods and contaminating the image. Rinse the fabric in cool water, then squeeze dry in a cotton terrycloth towel.

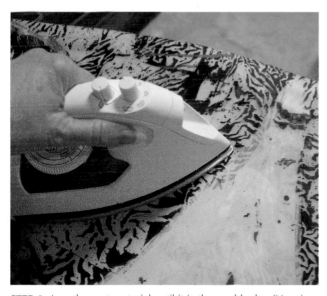

STEP 9 Iron the wet material until it is thoroughly dry. (Hanging it wet may cause the dye to bleed.) If there are several pieces to iron, iron them one at a time, leaving the unironed pieces floating in clear, cold water until you are ready for them. Once all the pieces are pressed, the material is ready for sewing.

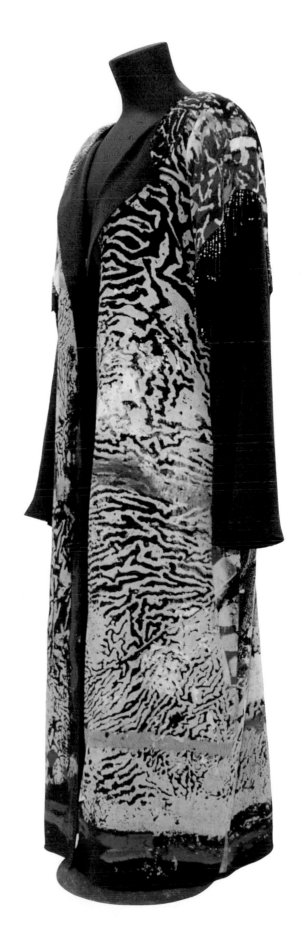

RIGHT: **Bonny Pierce Lhotka**
THUNDER COAT
Inkjet reactive dye on 23-mm silk crepe de chine. 2002.

DEMONSTRATION: Staining/Painting Underprint

MATERIALS

- protective gloves
- plastic sheet to protect work surface
- fabric (100-percent silk or cotton)
- steel rods or steel hardware objects
- white vinegar
- spray bottle
- plastic bag
- iron
- baby shampoo
- Bubble Jet Set 2000 precoat
- freezer paper
- Bubble Jet Rinse
- pigment inks for printer

HAND PAINTING or staining fabric creates a first layer over which a digital image may be printed. In this example, we stain a textile with rusting metal, and then overprint it with pigmented inks. Prepare by washing your chosen fabric to remove any sizing, iron it dry, then spread it on a smooth, hard surface.

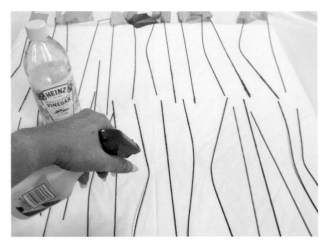

STEP 1 Place steel objects on fabric, then soak with white vinegar, sprayed on. Those yellow papers wrapped around the ends of the rods ease handling.

STEP 2 Cover the steel objects with a plastic bag and seal to keep the fabric from drying out while the vinegar is rusting the metal. If the objects don't lie flat, put weights on top of the plastic to keep the metal against the fabric. Leave covered overnight; the longer the metal remains sealed, the more the rust will bleed and spread.

STEP 3 When you want to stop the rusting process, remove the plastic and steel, let the fabric dry, then iron it to set the stains. Wash the fabric with baby shampoo to keep the white areas from being stained by excess migrating color. When the fabric is dry, fold it neatly and lay it in a tray. Pour in Bubble Jet Set 2000 and let soak for five minutes. Without wringing it out, hang the fabric on a clothesline until it dries thoroughly. Then iron the fabric to freezer paper, which will make it rigid enough to feed through your printer.

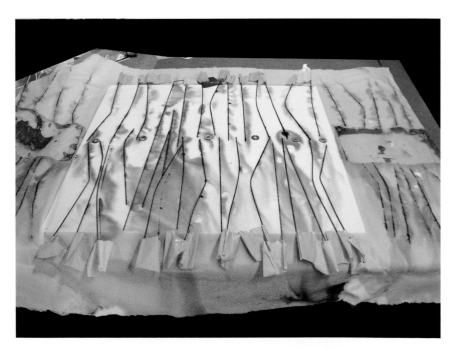

STEP 4 Take a digital photo of the fabric, then resize the digital file to match the dimensions of the actual fabric. This is similar to preparing a file for overprinting a collage; refer to earlier detailed instructions (page 45) for using a digital image as a template. The digital file of the underprint is now ready to have a digital image mapped over it. In Photoshop, add new layer(s) on top of the image of your fabric. These are the images you will print on the actual rusted fabric. It's best to develop an image that doesn't require precise alignment with the fabric.

STEP 5 A photograph of gladiolas is positioned over the image of the rusted fabric. Once you are satisfied with your composition, turn off or delete the layer containing the template image of the rusted fabric. Be sure you orient your fabric correctly (usually, top edge first) as you load it into your printer. Having prepared your printer with pigment inks, print on your fabric. Follow the manufacturer's instructions for washing and setting with Bubble Jet Rinse. Iron and finish. The printed cloth can be used as a collage element or sewn into a handbag, neckties, or other wearable art that does not require washing.

Once you scan a garment pattern, use it to create many different looks. These variations on a single pattern are for two blouses, three skirts, three sashes, and a jacket in coordinating colors and fabrics. One finished ensemble of dress and jacket is shown on page 150.

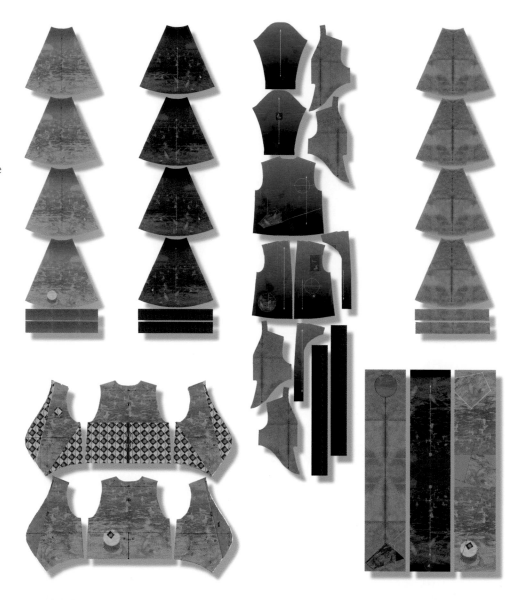

- Work in a well-ventilated area and avoid breathing in steam fumes during the ironing process.
- Acid and reactive textile dyes clog inkjet print heads more easily than inks. It's important to run a prime cycle every day so the ink doesn't dry in the heads. If the printer remains unused for long periods, it's best to drain the inks and flush the printer with cleaning fluids formulated for the inks you are removing.
- After printing on fabric, use canned air to blow any lingering dust out of the printer.
- When working with fabric, always set your printer's head height and media thickness selections to their maximum levels. On less-expensive printers, this may simply mean choosing the option for printing on envelopes.

- To create the most beautiful inkjet-printed, washable textiles, use acid or reactive dyes on 100-percent silk. To achieve the deepest blacks, use Lyson reactive dyes on silk or cotton.
- Make sure you do not maintain a full boil throughout the steaming-box step. That will cause the box to run out of water and scorch the fabric. Keep the water at a simmer.
- When ironing fabric on freezer paper for feeding through a printer, any loose thread or slight bubble where the fabric is not stuck to the paper may result in a head strike. Correct such problems before printing. If worse comes to worse, you may have to peel off the fabric completely and start over.

Creative Explorations

- Make a fine-art quilt on your desktop printer. The printed squares can be combined with solid-color fabric to expand the quilt's size.
- A readily available way to print on fabric is the iron-on, or heat-set, T-shirt transfer process. Many copy shops provide this service, and there are products that facilitate do-it-yourself application with your desktop printer. Some heat transfers also transfer well to 100-percent rag paper. Most heat-set fabric transfers have a slightly raised surface and a somewhat plastic quality.

If you have a wide-format printer, you can assemble an entire quilt digitally in Photoshop, print it in one piece, and then topstitch the fabric to give the impression that the squares have been pieced together, as in this example.

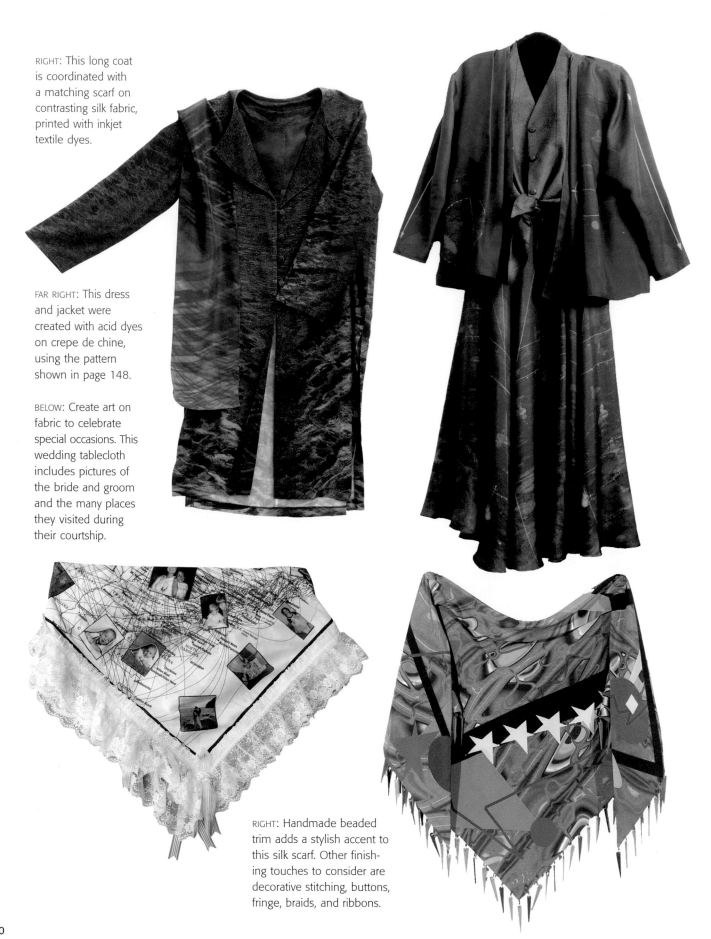

RIGHT: This long coat is coordinated with a matching scarf on contrasting silk fabric, printed with inkjet textile dyes.

FAR RIGHT: This dress and jacket were created with acid dyes on crepe de chine, using the pattern shown in page 148.

BELOW: Create art on fabric to celebrate special occasions. This wedding tablecloth includes pictures of the bride and groom and the many places they visited during their courtship.

RIGHT: Handmade beaded trim adds a stylish accent to this silk scarf. Other finishing touches to consider are decorative stitching, buttons, fringe, braids, and ribbons.

What's Next

The following pages contain a handy glossary of terms and resource information to serve as ongoing reference for your further ventures into digital printing. We hope to have inspired you to continue developing your skills for creating imaginative images that integrate your favorite art materials with today's newest inkjet printing techniques. Good luck with your journey!

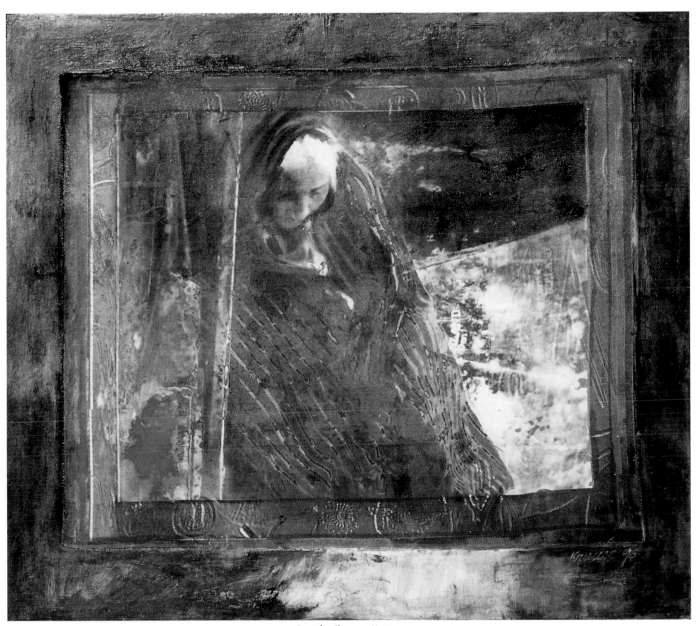

Dorothy Simpson Krause,
AGAINST THE WALL
Inkjet print on cotton adhered to painted plywood surround, 42 × 48" (106 × 122 cm), 1996.

Afterword: Looking Ahead

THIS WONDERFUL BOOK in your hands is a how-to manual for understanding the future. It is through the ideas of artists that all of us are made comfortable with the incredible changes that new technologies wreak upon us. According to Marshall McLuhan, "The artist picks up the message of cultural and technological challenge decades before its transforming impact occurs. He, then, builds models or Noah's ark for facing the challenge that is at hand."

Art is, by its very nature, a prediction. This is not to say that the message of art is prophesy. But the effects of new technologies can be invisible, and fine artists are so acutely attuned to the present that through their art come to understand technological and cultural challenges before they occur. It is in this sense that James Joyce's stream-of-consciousness prose and Cubist painting clarified the explosion of information technologies like radio and film and their effect on our later perceptions of reality.

As director of the Boston Cyberarts Festival, I'm often asked, What is coming next? What can we know about the future of art and technology? One thing we know is that things change; the pendulum swings both ways. At the moment, we live in a society where science and technology are in the ascendant, but a wariness of technology will surely return, as it often has in the past.

The Arts and Crafts movement of the late nineteenth century reacted against machine worship of the Industrial Revolution. But those artists didn't reject machines—only the shoddiness of machine-made products. In fact, the movement culminated in a successful synthesis of mass-production and hand-crafted methods. That result is similar to the message of this book: how artists can bring together the old and the new, retaining the finest qualities of each to best tell their tale.

Watching how artists approach new technology is a lesson in what will come next. Already, photographers, printmakers, and video artists have journeyed from the analog realm into a digital universe. Watching 3D artists take these first baby steps is yet another look at the path that began with the first electronic music generated almost fifty years ago. Only recently have 3D scanning and printers become accessible to artists. With those new devices, artists can bring objects into the

Karin Schminke
CONFLUENCE
Inkjet print on Arches Cover Black, triptych, 30 × 132" (77 × 336 cm), 2003.

computer, work on them within special software, and output them as sculpture. To the artist, the important part is the digital working environment—the software. Before computers, creation was a linear process. Now, it is a branching evolution where old paths can be revisited in an instant, and multiple procedures can be compared side by side.

Let us look at another breakthrough still in its infancy, nanotechnology, and think how artists might interact with it. For now, nanotechnology remains the material of physicists and engineers, but it has the potential to transform the world. I predict that it will be through the work of artists that we will come to understand the nature of that transformation. Nanotechnology is defined as the construction of machines smaller than a few-hundred nanometers, or billionths of a meter. These sophisticated machines will be built of atoms; computers can be constructed that are no bigger than a grain of salt. Futurists refer to this as "smart matter," because it can pass design instructions on to other matter. In the future, when we want a new product, we will send down the code to sheets of

smart-matter plastic that will rearrange itself into the object we seek, be it cell phone or sculpture. Today, we manipulate code in the computer and then output it on paper or videotape or as sculpture. At that moment, the effect of the code is at an end, and only the object remains. In the near future, code will have the ability to transform matter itself. Then code will remain, adapting to changing conditions, reacting to its environment and to the input of those who come in contact with it. Sculpture and prints will no longer be static, but interactive.

This is but one scenario for a future filled with wonder. Artists are the ones who are stepping into the future ahead of everyone else in terms of putting new technologies at the service of our creative spirit. And the best is yet to come.

George Fifield

Curator of New Media,
DeCordova Museum and Sculpture Park,
Lincoln, Massachusetts

Founder and Director,
Boston Cyberarts Inc.

Glossary

In addition to the following list, an extensive glossary of terms related to digital imaging will be found at www.dpandi.com.

ACID DYES For wool, silk, and cotton, these dyes hold permanently on cloth; set in inkjet-printed fabric by steaming. (See Reactive dyes.)

ACRYLIC MEDIUM Gloss or matte extender, thinner, or thickener for acrylic paint, dries to clear, flexible, non-yellowing finish; also used as glue.

ARCHIVAL Ages well with anticipated longevity.

BRAYER Roller for flattening, transferring, adhering surfaces.

BURNISH Smooth and polish a surface or help adhere it to another.

CALCIUM CARBONATE Natural compound used as whitening or thickening agent.

CHINE COLLÉ Paper adhered to a second, often larger, piece to make a single sheet.

COLD-PRESSED PAPER Roughly textured watercolor/printmaking paper.

CONTINUOUS INK SYSTEM Bulk container of ink that enables continuous operation over longer period than with original ink cartridge.

DAMAR Natural resin; dissolved in turpentine, yields a varnish, thickened stand oil, or glazing medium.

DYE INKS For inkjet printing, offers wider color range, but less permanence, than pigment ink.

EMULSION Suspension of mixture in viscous medium (as gelatin solution), to coat photographic plate, film, or paper.

ENCAUSTIC Process of painting with melted wax.

FLATBED PRINTER Printer that supports irregular and other surfaces up to a foot thick.

FRESCO Plasterlike surface made of calcium carbonate and binder; painted into while wet.

FRISKET paper or liquid masking device. (See Mask, Resist.)

FULL-BLEED Borderless image printed to edge of paper or other surface.

HEAT PRESS Machine used to transfer images or embossing.

HOT-PRESSED PAPER Smooth-textured watercolor or printmaking paper.

INTAGLIO Printing method with plate having image sunk below surface. Recessed areas are filled with ink; paper is forced into grooves to pick up ink.

INTERFERENCE PIGMENTS, PAINT Colors that shift with viewing angle and light, appearing to flip between two colors; contains reflective material such as mica.

LAMINATOR Roller device that adheres two items together; also used as a press to transfer images.

LASER PRINTER Output device based on photocopier principle; laser beam writes on photoconductive drum coated with toner that transfers to paper to create an image. Four or more different colored toners may be used.

LCD Liquid crystal display screen often used as a computer monitor.

LEADING EDGE The edge of paper fed into the printer first.

LENTICULAR Technology that creates print images that appear to have depth and/or animation.

LETTERPRESS Printing from a raised inked surface pressed on paper, resulting in lightly debossed type.

LIGHTFAST The length of time a print will retain color before fading.

MASK Material used to protect an area from being painted or altered. (See Frisket, Resist.)

MEDIA In digital printing, term used for surface on which the image is printed. (See Substrate.)

MICROPOROUS An inkjet receptor coating that encapsulates ink as it strikes media.

NONPOROUS Hard surface that does not absorb water.

NONWOVEN FABRIC Flat, porous sheets of polyester or polypropylene; will not warp, stretch, or shrink. (See Spun-bonded polyester and polypropylene.)

PEARLESCENT Pigments/paints containing mica particles that produce color by reflecting light, creating lustrous surfaces.

PIEZO Inkjet technology that uses electricity, rather than heat, to fire printhead, producing far higher resolution. (See Thermal printer.)

PIGMENT INK For inkjet printing, offers more permanence than dye ink, but with more restricted color gamut. (See Dye inks.)

PIZZA WHEELS Serrated-edged wheels that move paper through printers. If in front of printheads, they may track through wet ink, damaging print and/or printer.

PLANOGRAPHIC In printmaking, surface with ink on its flat plane, as opposed to being engraved or embossed to hold ink.

POLYCARBONATE Hard, clear plastic sold in sheets and panels.

POLYESTER FILM Film widely used for commercial inkjet media.

POLYPROPYLENE Translucent or white plastic that almost nothing will adhere to; sold in rigid sheets $1/16$" or thicker. Plastic trash bags, rolls of landscape sheeting, and drop cloths are forms of flexible polypropylene.

POROUS Having pores that allow moisture to be absorbed.

POSTCOAT Clear material applied as final coat to protect prints/artwork.

PRECOAT Receptor coating on inkjet media to improve color/clarity of a print, enhance adherence of water-based ink, and speed drying.

PRINTER DRIVER Software that lets computer communicate with printer. (See RIP)

REACTIVE DYES Soluble substance for dyeing cotton and cotton/poly blends; dyes hold permanently on cloth; set in inkjet-printed fabric by steaming. (See Acid dyes.)

REGISTRATION Alignment of an image for a particular placement.

RELIEF PROCESSES Printing plates that are incised, etched, or sand-blasted before surface is inked. Areas cut away do not print; ink is transferred from plate to paper by hand rubbing or with a press.

RESIST Material applied to selected areas of a surface to prevent ink/paint from adhering. (See Frisket, Mask.)

RIP Raster Image Processor, or softwear, that interfaces between computer and printer to transfer image from screen to paper. Offers more image control than printer drivers. (See Printer driver.)

SERVICE BUREAU Business providing specific digital services usually pertaining to output.

SILKSCREEN Sophisticated stencil process also known as serigraph.

SIZING Solution applied to a surface to reduce its absorbency or porosity, rendering it more receptive to paint or other art material.

SPUN-BONDED POLYESTER OR POLYPROPYLENE Fabric that will not warp, stretch, or shrink. (See Nonwoven fabric.)

STRAIGHT PAPER PATH Paper moves through printer without curving or bending.

SUBSTRATE Underlying surface for paint, print, or transfer. (See Media.)

TARLATAN Cheeseclothlike fabric of various weights and stiffness used in printmaking.

THERMAL PRINTER Inkjet printer using heat. (See Piezo printer.)

TOOTH Texture, or grabbing ability, of a paper's surface.

TRANSFER Moving an image from one surface to another.

UV-CURABLE INKS Inks cured with ultraviolet light to increase permanence.

UV-PROTECTIVE GLAZE For framing art, glass or acrylic sheet that filters out UV rays to prevent fading.

VITREOGRAPHY Printmaking using glass plates for intaglio or planographic processes. (See Intaglio, Planographic.)

WATERLEAF PAPER Paper made with little or no sizing. (See Sizing.)

WATER-RESISTANT Surface that resists dampness, but not a soaking of water, as would a waterproof surface.

WATER-SOLUBLE The ability to dissolve in water.

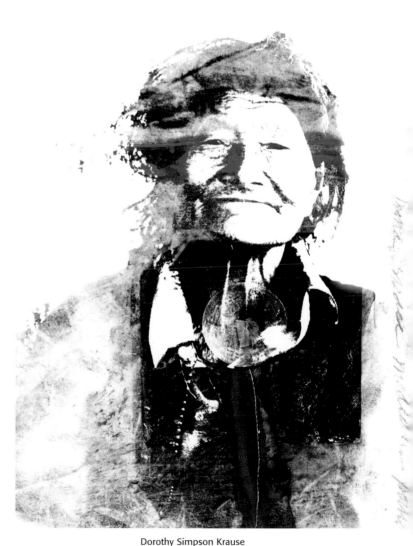

Dorothy Simpson Krause
WISEWOMAN
Inkjet transfer to watercolor paper,
35 × 28" (87 × 71 cm), 2000.

Resources

General Information

AUTHORS COLLECTIVELY

Digital Atelier
www.DigitalAtelier.com

AUTHORS INDIVIDUALLY

Karin Schminke
Karin@Schminke.com
www.Schminke.com

Dorothy Simpson Krause
DotKrause@DotKrause.com
www.DotKrause.com

Bonny Pierce Lhotka
Bonny@Lhotka.com
www.Lhotka.com

DIGITAL INFORMATION

Digital Printing and
 Imaging
www.dpandi.com

Digital Fine Art Discussion
 Group
http://groups.yahoo.com/
 group/digital-fineart

Hardware

CAMERAS

Olympus
(800) 622-6372
www.olympus.com
*Olympus C-5050 and
E20 are used for
authors' photography
of artwork for Web and
print use.*

DIGITIZING OR DRAWING TABLETS

Wacom Technology
(800) 922-9348
www.wacom.com

INKJET PRINTERS

Epson America
(800) 922-8911
www.epson.com

Encad/Kodak
(800) 453-6223
www.encad.com

Mutoh America
(602) 414-4613
www.mutoh.com

LASER PRINTERS

Xerox/Teltronix
(888) 247-5107
www.office.xerox.com

SCANNERS, SLIDE AND FLATBED

Microtek
(310) 687-5800
www.microtek.com

Software

DIGITAL IMAGING

Adobe Photoshop
(800) 833-6687
www.adobe.com

RASTER IMAGE PROCESSOR (RIP)

Wasatch Computer
 Technology
(800) 894-1544
www.wasatchinc.com
*Wasatch SoftRIP has
textile feature for step
and repeat patterns.*

CADlink Technology
(800) 545-9581
www.cadlink.com
*PhotoScript RIP creates
lenticular prints.*

Art Materials

For general and specialized
art supplies not found at
local dealers:

Daniel Smith
(800) 426-7923
www.danielsmith.com
*Request catalog; wide
selection of materials,
including digital fine-art
papers.*

Fredrix Artist Canvas
(800) 241-8128
www.fredrixartistcanvas.com
*Makes widely distributed
raw linen canvas, stretcher
bars, and related items.*

Golden Artist Colors
(800) 959-6543
www.goldenpaints.com
*Makes widely distributed
Mineral Spirit Acrylic,
Acrylic Flow Release,
and other paints and
mediums.*

Liquitex Artist Acrylic
(888) 422-7954
www.liquitex.com
*Makes widely distributed
acrylic products.*

CONTINUOUS INK SYSTEM

Lyson Ltd.
(847) 690-1060
www.lysonusa.com
*Makes Cave Paint
Continuous Ink System.*

ENCAUSTIC

R & F Encaustic Supplies
(800) 206-8088
www.rfpaints.com

FABRIC PRINTING

Lyson Ltd.
(847) 690-1060
www.lysonusa.com

Beaver Paper
(800) 768-2700
www.beaverpaper.com
Fabric-backing papers.

Bubble Jet Set/C. Jenkins
 Necktie & Chemical
(314) 521-7544
www.cjenkinscompany.com
Fabric precoats.

Color Textiles
(702) 845-5584
www.colortextiles.com
*Mounted fabrics for
desktop printers.*

DigiFAB Systems
(213) 689-3400
www.digifab.com
Inkjet-printable fabrics.

Jacquard Inkjet Fabric
 Systems
(800) 442-0455
www.inkjetfabrics.com
*Backed fabrics for
acid/reactive dyes.*

3P Inkjet Textiles
(203) 245-2509
www.3p-inktextiles.com
Pretreated, mounted fabrics.

Sawgrass Solutions
(843) 884-1575
www.sublimation.com
Dye sublimation products.

FRESCO SUPPLIES

Quickcrete and Baltic
birch plywood are found
at lumberyards and/or
hardware stores; calcium
carbonate, at hardware
stores; glycerine, at drug
stores; Knox unflavored
gelatin, at supermarkets.

Art Boards
(718) 237-2592
www.art-boards.com
Cradled panels for fresco.

GLUES, ADHESIVES

Sold in art-supply stores. For finding more about glues:
www.thistothat.com
www.adhesivesmart.com

INKJET SUPPLIES

InteliCoat Technologies
(800) 343-0818
www.magicinkjet.com
Inkjet film, canvas, and archival paper, including Arches by Magic.

Global Imaging
(303) 637-9773
www.globalimaginginc.com
Sells Mutoh, ZUND, Epson, and Kimoto printers; inkjet inks, media, and Océ film.

Kimoto Tech
(888) 546-6861
www.kimototech.com
Web site lists dealers for SC4, used in transfers.

Océ-USA
(800) 523-4827
www.occusa.com
FCPLS4 4-mil clear film for wet transfers.

DuPont
(877) 234-1794
www.dupont.com/inkjet/ fusioninks
Fusion pigment inks for Encad thermal inkjet printer.

LENTICULAR

CODA
(201) 825-7400
www.codamount.com
Cold laminators also used as monotype press for wet transfers.

MicroLens Technology
(704) 847-9234
www.microlens.com
Introductory package includes free software with lens purchase.

MACtac
(330) 688-1111
www.mactac.com
Sells crystal-clear adhesive film for mounting lenticular lens.

FlipSigns!
(702) 384-0568
www.flipsigns.com
Makes SuperFlip! and 3D Genius! lenticular software; also a source for training.

Graphic Media
(800) 533-5206
www.gmpinc.com
Makes tool for scratch-free dust removal from any surface, essential for mounting lenticular prints.

PAPER

Digital Art Supplies
(877)534-4278
www.digitalartsupplies.com
Distributes art papers coated for inkjet, including precoated rice papers, Hahnemühle, Somerset, and others.

Arches (Canson USA)
(800) 628-9283
www.canson-us.com
Makes widely distributed fine-art papers.

Legion Paper West
(800) 727-3716
www.legionpaper.com
Distributor of numerous art papers, including Japanese and Thai uncoated.

Twinrocker Handmade Paper
(800) 757-8946
www.twinrocker.com
Makes archival inkjet handmade papers, and carries related items.

PLASTICS

For rolled and sheet plastics not found at local hardware stores or other outlets specializing in plastics:

Laird Plastics
(800) 610-1016
www.lairdplastics.com
Sheet plastics; Web sales and stores across the United States and Canada.

Talas
(212) 219-0770
www.talasonline.com
Sells Reemay, a spun-bonded polyester fabric, extensive pigments, and other art supplies.

Grafix Plastics
(800) 447-2349
www.grafixplastics.com
Makes DuraLar polyester films for wet transfers; Web site lists retail outlets.

Graphic Chemical
(800) 465-7382
www.graphicchemical.com
Distributes Pronto polyester plate, ImageOn, tarlatan, SolarPlate, etching presses, and other printmaking supplies.

POSTCOATS

Clearstar Coatings
(888) 253-2778
www.clearstarcorp.com
ClearShield Type C liquid laminate in gloss, semi-gloss, and matte postcoats for matte canvas and inkAID white matte precoat.

PRECOATS

inkAID
(888) 424-8167
www.inkAID.com
Universal inkjet precoats for all processes.

SERVICE BUREAUS

Zinc Studios
(800) 303-8833
www.zincstudio.com
Banner printing and fabrication.

Digital Thermal Graphics
(303) 444-4649
www.dtgpromo.com
Dye sublimation.

VanGogh Again
(303) 926-0243
www.vgae.com
Large-format scanning.

Liquid Metal Coatings
(303) 202-2042
www.liquidmetalcoatings. com
Will coat any material with real metal.

Applied Visual Concepts
(616) 546-3543
www.appliedvisualconcepts. com
Zund flatbed printer with UV-cured inks, prints on glass, composite, and shaped surfaces up to an inch-and-a-half thick and seven feet wide.

TRANSFERS

Lazertran LLC USA
(800) 245-7547
www.lazertran.com

BelDecal
(305) 593-0911
www.beldecal.com

Index

Authors' Biographies

Karin Schminke

Now based in Seattle, Karin Schminke studied basic programming in a computer course for artists while pursuing her M.F.A. degree at the University of Iowa in 1978. Her interest in the integration of digital tools with traditional art media and techniques has influenced her work since that time. Throughout a fifteen-year teaching career at the University of Wisconsin-Eau Claire, California State University Northridge, and the Art Institute of Southern California, her major interest remained the assimilation of the newly developing digital tools into the artist's studio.

Since 1994, Schminke has worked full time as an artist, moving freely between digital and traditional tools in her studio. Her art uses layered print techniques to reflect the complexities of the natural world's patterns and forms. Her art also explores subtle intricacies of relationships that are woven together into expressive views of the subject matter that become icons for meditation and contemplation.

Dorothy Simpson Krause

Since she was introduced to computers in the late 1960s while completing her doctorate at Penn State, Dorothy Simpson Krause has used digital technology for research, communication, information management and creative exploration. During her twenty-seven years at the Massachusetts College of Art, where she served as graduate dean, vice president, and professor of computer graphics, she computerized administration facilities and began the Computer Arts Center.

Based in Boston, Krause is a painter and collage maker who uses the computer as her primary art-making tool. Her richly surfaced work embeds archetypal symbols and fragments of image and text in multiple layers. It combines the humblest of materials—plaster, tar, wax and pigment—with the latest in technology, to evoke the past and herald the future.

Bonny Pierce Lhotka

A graduate of Bradley University in printmaking and painting, Bonny Pierce Lhotka is an experimental artist who invents tools and process to create art in her Boulder, Colorado, studio. The addition of the computer enabled her to incorporate photography in her work; she first used the Apple computer as an art tool in 1982 to create plates for black-and-white block printing.

Lhotka's visually rich vocabulary, encompassing fragments of objects, dreams, and reality, illuminates the connection between life and death, technology and the human spirit. Meaningful symbolism and a sense of continuum links time and space in her work, which has been commissioned by hundreds of corporations and public-art projects, including the US Department of State. Her work has also appeared in dozens of books and periodicals.

Bonny Pierce Lhotka
MEMORIES
Inkjet print on precoated, distressed white polycarbonate,
24 × 24" (61 × 61 cm), 1992.